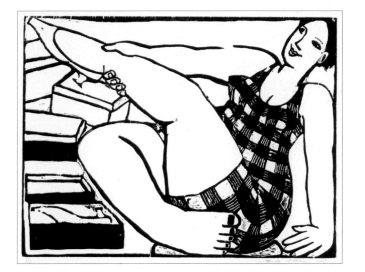

THE INSTANT **PRINTMAKER**

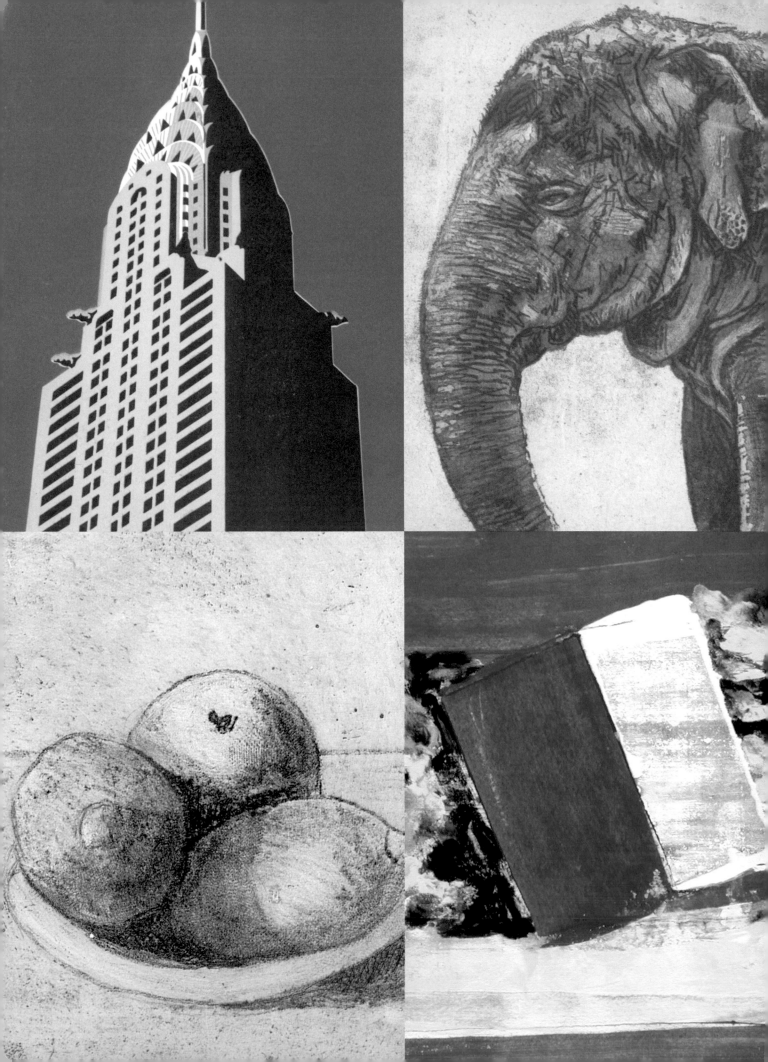

THE INSTANT
PRINTMAKER

PRINTING METHODS TO TRY AT HOME AND IN THE STUDIO

MELVYN PETTERSON AND COLIN GALE

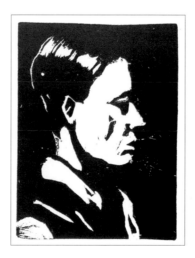

WATSON
GUPTILL

First published in the USA in 2003 by
Watson-Guptill Publications,
A division of VNU Business Media, Inc.,
770 Broadway,
New York, NY 10003
www.watsonguptill.com

First published in Great Britain in 2003
by Collins & Brown Limited
The Chrysalis Building
Bramley Road
London W10 6SP

An imprint of Chrysalis Books Group plc

The right of Melvyn Petterson and
Colin Gale to be identified as the authors
of this work has been asserted by them in
accordance with the Copyright, Designs and
Patents Act, 1988.

1 3 5 7 9 8 6 4 2

Library of Congress Control Number:
2003109618

ISBN 0-8230-2526-8

Publisher: Roger Bristow
Photography by George Taylor
Designed by Roger Hammond
Project managed by Emma Baxter
Copy-edited by Chris George

Reproduction by Classic Scan Pte Ltd,
Singapore
Printed and bound by Imago Ltd, Singapore

CONTENTS

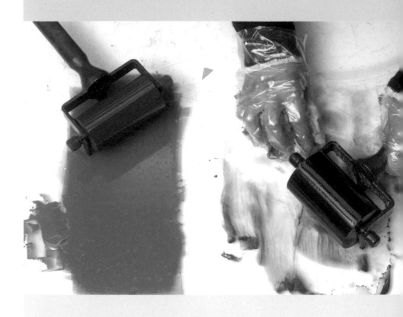

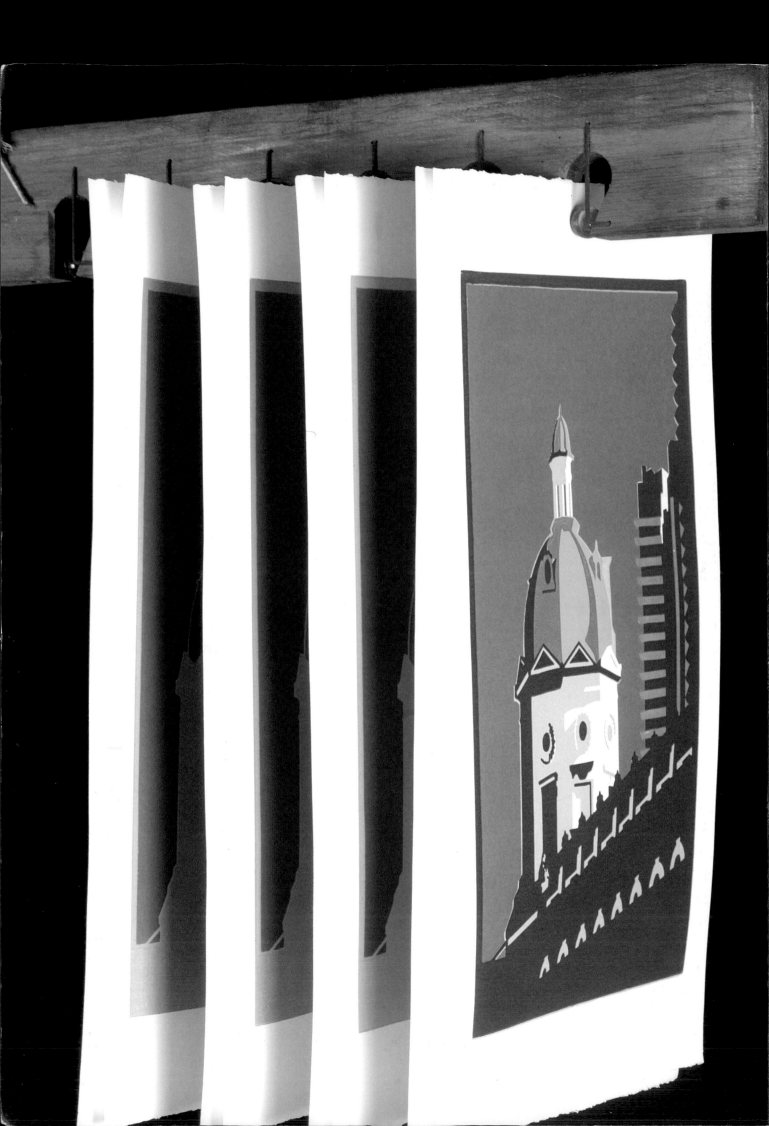

Introduction

Centuries before the advent of paper manufacturing, man used instant print techniques to communicate words and symbols. Rubbings, carvings, seals, stamps, stencil decorations, engraved metals—printmaking is a fusion between century-old techniques and modern-day technology.

Printmaking has a unique position in image making. The design, drawing, and craftsmanship employ aspects of painting, sculpture, and photography. The possibilities are so varied and versatile that printmakers can bring together elements from all of these disciplines—combining them in an exciting melting pot of structure, form, composition, and expression.

The Instant Printmaker offers practical, how-to advice on printmaking. Clear, illustrated step-by-step projects explain each technique and include a full list of the tools and materials required. Each project is followed by a gallery of artists' prints revealing the wide range of images possible with each technique. These gallery images were kindly supplied by members and colleagues of Artichoke Print Workshop, London.

The techniques demonstrated in this book are divided into two sections. In the first, the techniques described are ones that can be carried out at home with basic equipment using hand-printing methods or a simple bookbinder's press. In the second section, techniques that require a more sophisticated printing press are explained.

It is the authors' intention to encourage an enjoyment of printmaking and image creation. Printmaking is a craft that, through time, can be mastered and combined with artistic endeavor to produce beautiful results. *The Instant Printmaker* gives a taste of the multitude of mark-making techniques and the creative possibilities which, for us, have led to a life long passion for the printed image.

Colin Gale and Melvyn Petterson

Tools and Materials
Health and safety equipment

All types of printmaking involve various degrees of risk, whether it be the inherent danger of sharp tools or the hazards posed by certain chemicals. Health and safety should, therefore, be every printmaker's personal concern and a collective responsibility if working with others in a studio or classroom.

Print studios, or printmakers making a living from their work, are also subject to local health and safety laws and guidelines. Precise legislation on health and safety varies from country to country, and from state to state, but usually the conditions that govern printmaking studios will come under the safety at work legislation applicable to where you live.

For the most part, health and safety are little more than applying basic common sense. They involve using the correct safety equipment for the task in hand, as listed below. They also require observing good hygiene—no eating, drinking, or smoking in the studio—and keeping a clean and tidy work environment. Maintain a file listing all the chemicals and solvents used in the studio and keep with it their relevant datasheets which detail their associated hazards and necessary safety precautions.

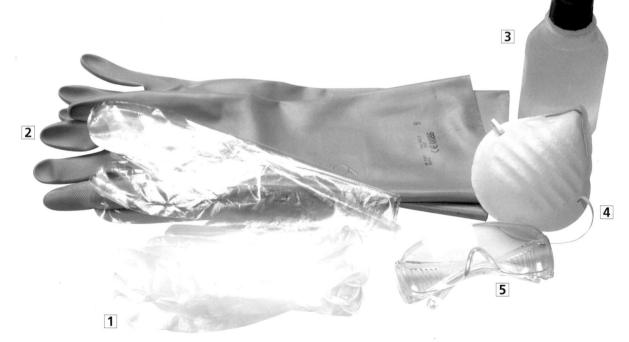

Safety equipment
1 Disposable gloves, made from rubber, plastic, or latex. These can also be useful while inking—particularly when inking intaglio plates—to keep the hands clean for when the time comes for handling the paper. Also useful for general cleaning up of ink.
2 Heavy duty gloves usually made of rubber. These should be used for handling chemicals, solvents, etching acids, and other caustic substances.
3 Disposable eye wash solution for emergencies with solvent or chemical splashes. Eye wash is a first aid precaution only; always call for professional medical advice if an eye splash occurs.
4 Dust masks—to be worn when using aquatint rosin (resin).
5 Safety goggles. Wear at all times when using chemicals.
6 A basic first aid kit should be on hand containing an assortment of bandages.

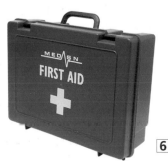

The right tools

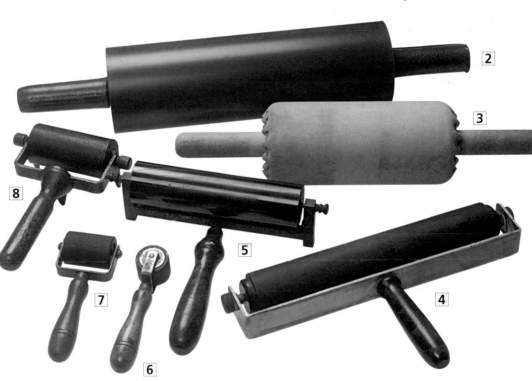

Brayers (Rollers)

It is helpful to have an assortment of sizes of brayers (rollers) for inking. Quality ones are expensive but if cared for correctly will last many years. You get what you pay for, and sometimes the economy brayers (rollers) do not work out to be financially viable in the long run. For many techniques the same brayers (rollers) can also be used uninked for hand-printing, burnishing the inked plate to the paper.

1 Spindle brayer (roller) with stand and hand grips
2 Spindle brayer (roller)
3 Leather nap litho brayer (roller)
4 Large hand brayer (roller) (hard)
5 Large hand brayer (roller) (medium)
6, 7 Small rubber brayers (rollers)
8 Medium-sized rubber brayer (roller)

Palette knives

Palette knives are used for handling ink. Two types are needed: long, flat knives are used for general ink preparation, while wide-bladed scrapers and putty (push) knives are for heavy duty mixing. Always clean knives after using each color, so that cans of ink do not become contaminated. Putty (push) knives can also be used for handling hot metal plates, after they have been heated for various etching processes.

For screenprinting metal palette knives are not used to move the ink on the mesh, since these may damage the screen. Cardboard strips or plastic palette knives are used instead.

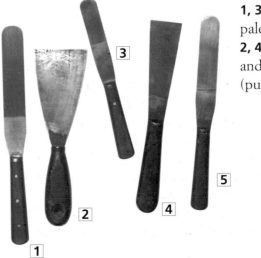

1, 3, 5 Flat palette knives
2, 4 Scraper and putty (push) knives

Plastic trays

Plastic developing trays, the kind used in photographic darkrooms, are needed both for soaking paper before printing and for acid baths. Keep separate trays for the two purposes to avoid cross-contamination—soaking paper in a tray that has previously been used for acid will damage the paper. Large trays need to be strong due to the volume of liquid they will contain. Consider having plug holes fitted to larger trays for easy draining.

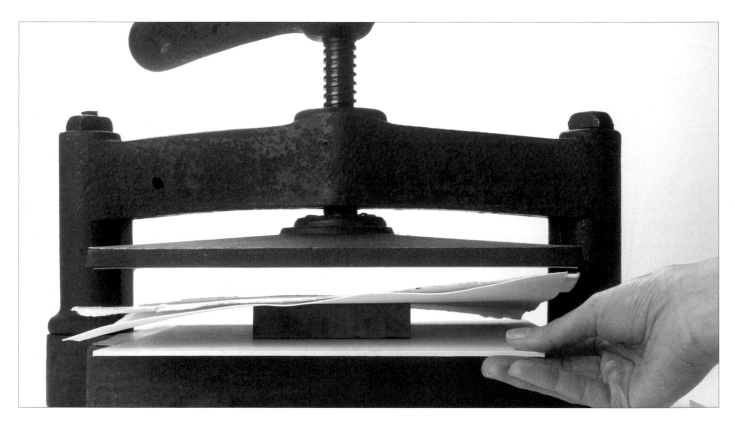

Presses

Many new alloys have been introduced in recent years, so presses no longer have to be made from heavy cast iron. Free-standing and table-top presses are also now made in many sizes, so that it is perfectly possible for printmakers to have their own press at home.

There are many different types of presses available—old, new, and antique. Many were designed with other things in mind, but most can be adapted for use for the majority of printmaking techniques. Relief or platten presses, for instance, were manufactured for printing with lead type. Perhaps the most versatile type of press for the printmaker is an intaglio or etching press (two etching presses are pictured opposite—the top press is a

lightweight portable model, the bottom press is a more traditional etching press). Intaglio or etching presses have the advantage of a top roller which can be adjusted vertically so that plates and relief blocks of different thicknesses can be printed. Litho presses, primarily designed for lithographic printing, can also be used for most intaglio techniques. A low-tech solution is to make your own press, converting an old washing mangle by adding a plank for a bed.

A letter (or nipping) press (pictured above, and used on p.52) is very useful for many printmaking techniques. Also known as a bookbinder's or screw press, this is small and portable, making it perfect for home use.

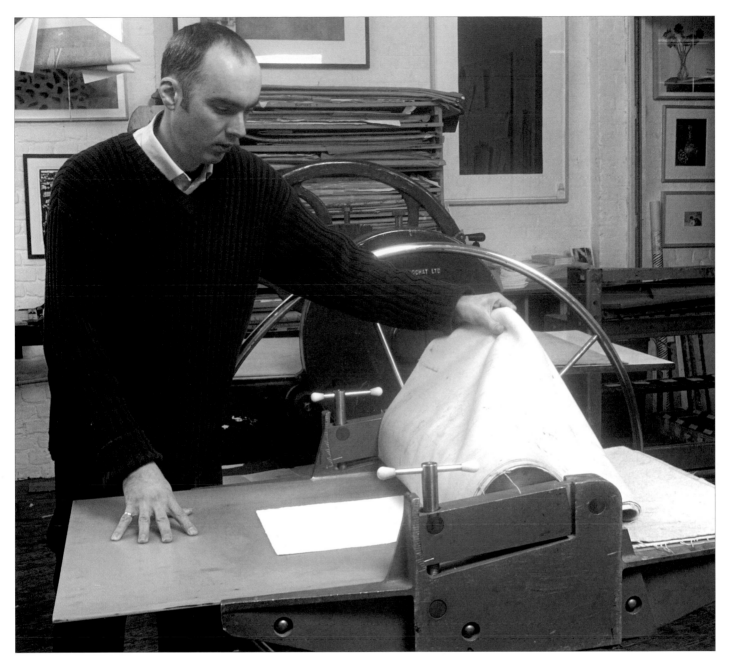

Press blankets

A good set of press blankets is essential (see blankets being peeled back on etching press above). These are tailor-made to cushion the plate while it is being printed and to protect the press. The best are made of woven wool.

Blankets are very expensive and should be looked after carefully. Check that metal plates are well bevelled (by smoothing the edges and corners) with a file, and make sure that you do not run

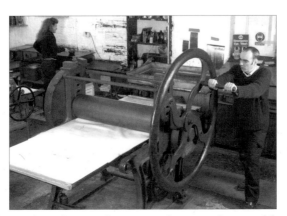

sharp or hard objects through the press—if the blankets get cut they are useless.

Blankets will absorb starch from damp paper and become stiff after heavy use. Keep them soft by washing them in a washing machine on a cool wool cycle every few months.

For plates with very heavy textures, such as in collagraphs, substitute foam rubber mats, the kind used under sleeping bags when camping out, for the wool blankets.

Oil-based and water-based inks

In recent years an increased awareness of health and safety issues has seen a change in inks available for the printmaker. The most significant developments have been in screen printing. It is now rare to find a college or an art workshop that still uses oil-based screenprinting inks— because of the solvents needed for washing the screens. All major ink manufacturers now concentrate on supplying ranges of water-based screenprint ink.

Relief printing inks still offer a choice between oil-based and water-based inks. Most individual printmakers still favor oil-based inks since these consistently perform better. For school groups, younger students, and for those wishing to avoid handling solvents, water-based inks are the sensible option.

Oil-based inks must be used for etching, since printing is carried out using damp paper. The most common color is black, giving the printmaker a surprisingly wide range of choices. Apart from different brands, manufacturers provide black inks that vary greatly in intensity and consistency.

For all-purpose work, choose a black that is described as "easy wiping." This will save time when wiping the plate with tarlatan (scrim) prior to printing in comparison to a heavily-pigmented, stiffer ink.

Etching ink can be made by mixing ground pigment together with copperplate oil (a refined linseed oil). This is quite time-consuming, however, and it is more convenient to buy ready-mixed cans or tubes. Etching ink can also be bought in cartridges for use with a caulking gun (the type used for mastic by decorators and builders). The cartridges have the advantage over cans that the ink does not dry up or form a skin.

1, 2 Small rubber brayers (rollers) and litho ink
3, 4 Medium rubber brayers (rollers) and litho ink
5 Putty (push) knife and litho ink

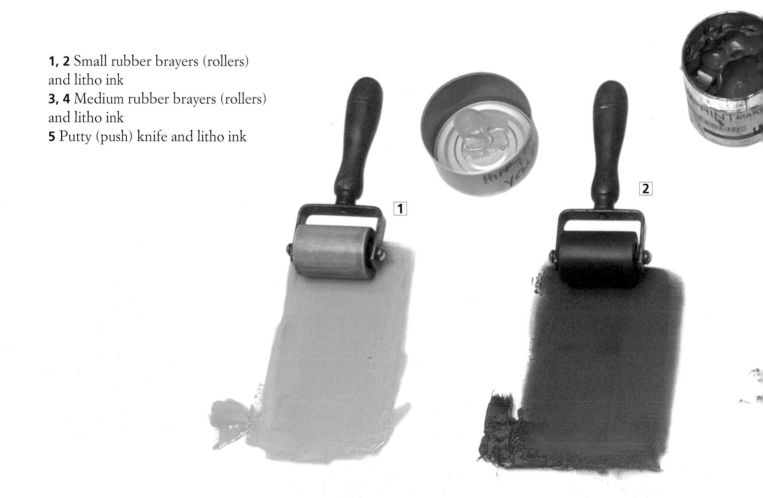

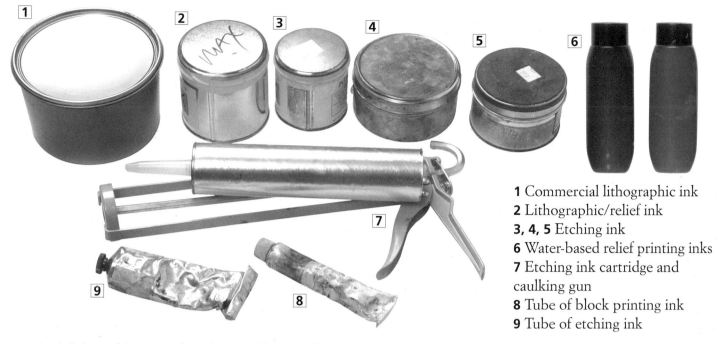

1 Commercial lithographic ink
2 Lithographic/relief ink
3, 4, 5 Etching ink
6 Water-based relief printing inks
7 Etching ink cartridge and caulking gun
8 Tube of block printing ink
9 Tube of etching ink

With lithography, as with etching, oil-based inks must be used for technical reasons. Whole color ranges are available in cans for the printmaker. Lithographic inks can also double as relief printing inks.

Suppliers (see p.128) sometimes give strange names to colors (not the traditional oilpaint names), therefore it is best to ask to see a color chart when choosing colors. Finally, don't be afraid to mix different colored inks together. Mix a little at a time, rubbing the color onto a piece of scrap paper to see what it looks like.

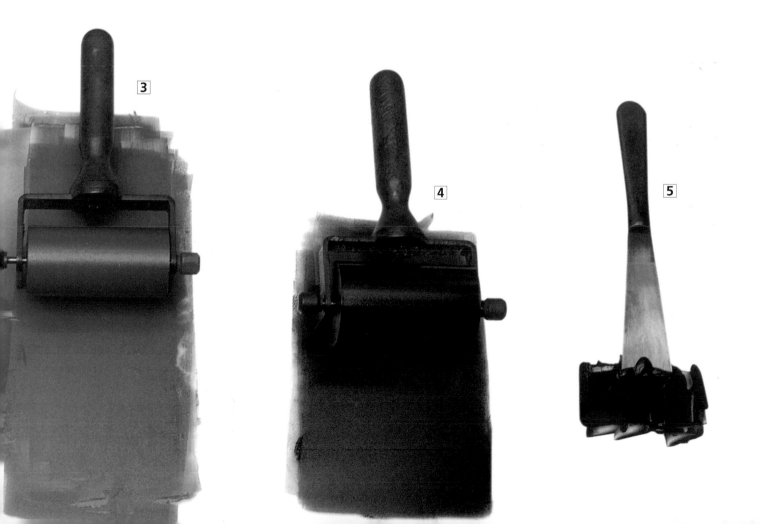

Papers

The diversity of papers available for printmaking is huge. Papers vary in surface texture and weight, as well as in color. Make sure that the paper you use is acid-free, however, or it will turn yellow over time (most paper sold by good suppliers will be acid-free).

Mold-made papers are the most useful for print-makers. These have been made with the same quality ingredients as handmade paper, but unlike handmade paper, each sheet is machine manufactured and not individually cast. Mold-made paper is distinguished by its two deckled edges (the uneven, untrimmed edges characteristic of handmade papers); the other two edges are either torn or cut.

It is predominantly made from cotton fiber rather than wood pulp. Mold-made paper is sold using the traditional sizes of 22 x 30 inches (560 x 760mm) and 30 x 44 inches (760 x 1120mm). Most press manufacturers build their machine bed sizes based on the standard paper sizes.

Paper weight is either expressed in pounds (for each 500 sheets) or in grams per square meter (gsm). The most useful weight for printmakers in terms of handling and printing quality is 100–140 lb (200–300gsm).

Paper also varies significantly in its "sizing"—the glue (size) that is added to paper to give it strength. Internal sizing is added to the pulp during manufacture, while external sizing is added as a coat to the finished sheet. Known as waterleaf paper, some paper is unsized.

Paper suppliers often have sample packs that allow you to compare the different colors, textures, and finishes of their ranges.

Which paper?

Print the same image onto a white sheet and onto an off-white sheet and compare the results. You'll find even this small change makes a huge difference to the look of the print. There are so many variables when choosing paper that it is worth talking to your supplier about which types they recommend for a particular process. Here are some general guidelines:

- Water-based screenprinting—use externally-sized paper. This reduces paper buckling since the size prevents water absorption. Use smooth surfaces.

- For hand printing—choose smooth surfaces and lighter-weight papers.
- Relief printing—use unsized or lightly-sized paper with a smooth surface; this will be the most sensitive.
- Etching—use sized paper for its strength. Due to the enormous pressure exerted while printing, heavily textured paper may be used. A marvelous contrast can be achieved between the textured outside border of the print and the smooth central image area where the plate has flattened the paper.
- Lithography— select sized paper for strength with a smooth surface to pick up detail.

It is good to experiment with a range of colors. Manufacturers will often make the same paper in various shades of white, buff, and sandy colors, grays, and black.

Dampening paper

For all intaglio printing—all the etching, collagraph, and drypoint techniques in this book—the paper must be printed damp. The paper is completely immersed in clean water in a tray or sink specifically kept exclusively for this use. Soaking serves to fluff up the fibers and soften the paper by removing the size. This allows the paper to pick up the maximum detail, as the paper surface molds itself into every groove.

Each sheet of mold-made paper should be individually placed into the water and soaked for at least 15 minutes before it is printed. Heavily-sized paper will need longer. Leaving the paper to soak for several hours will not harm it but it's always best to handle wet paper with care. It is also good practice to handle the paper using paper grips (small strips of paper folded in half) as these will help to keep it clean.

Prior to printing, remove the paper from the tray or sink and hold it up by one corner to allow the excess water to run off. Carefully place the paper between sheets of clean blotting paper. Using hand pressure blot the paper until no excess water is apparent on its surface. Now the paper is ready to print.

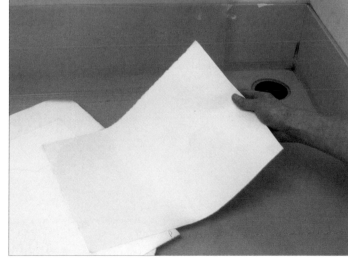

Slide each sheet into the water individually. Handle the dampened paper carefully since it tears easily when wet.

Once you have blotted the wet printing paper, peel back the blotting paper to see if water is still visible on the surface of the printing paper—if it is not, it is ready to use.

Registration

Registration for multi-colored prints is the process that guarantees the different color layers line up correctly when printed one on top of the other. With one-color prints, registration means printing the image squarely onto the paper with the required margins. Each printmaking technique has its own system.

To register relief prints and lithographs

The simplest way to achieve this is to mark out a "backing sheet" for positioning both the block or plate and the printing paper.

First, make sure your sheets of paper are cut or torn to the same size. Take one sheet and place the block or plate face up in the center of it; draw round the edges with a pencil. These pencil marks will serve as the positioning guide for the block or plate when it is inked and ready to print. Since the printing paper is identical in size to the backing sheet, the two are simply lined up corner to corner with each other prior to printing.

It is important that the same backing sheet is kept for each subsequent color layer.

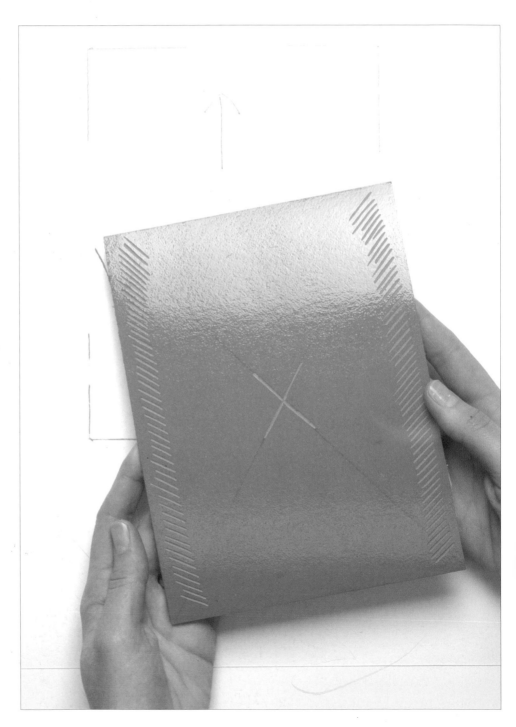

A spare piece of paper, the same size as that used for printing, is used as a backing sheet. The position where the plate or block is to be positioned is marked on this. Each sheet of printing paper is then aligned with the backing sheet for each color printed.

To register etchings

When the plate is at a stage where it can be printed, the press bed needs to be marked up for registration. If you are working on an etching press by yourself, mark out the bed itself. If you are sharing the press with others, use a thin sheet of acetate that can be removed from the bed after you print. The permanent marker lines can be removed later with denatured alcohol (methylated spirit).

 Tear the paper to the required size (use whole, half, or quarter sheet depending on plate size). Mark out the acetate or bed using a permanent marker. First, draw around the corners of your printing paper. Next place the plate in a position central to the corner marks. Use a ruler to measure the margins—the top and side margins should be equal, with a wider margin at the bottom. Draw around the plate. These marks identify where to put the plate and paper when printing.

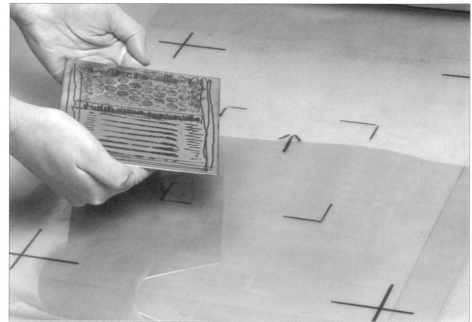

Registration marks can be put on the press bed directly, or they can be drawn onto a sheet of acetate using permanent marker.

Don't forget to place tissue under the plate to keep the bed/acetate clean and keep the permanent marker from rubbing onto the paper.

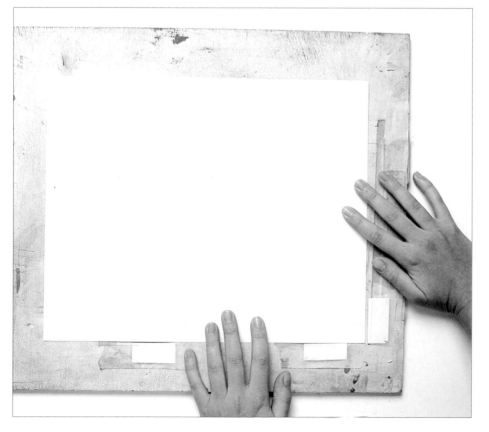

To register screenprints

When screenprinting, the first sheet of paper is carefully positioned under the mesh by looking through the mesh and moving it until it lines up correctly with the stencil that is about to be printed. Once the paper is in position, register it using three cardboard strips held down with masking tape—two strips at the bottom right hand corner and one strip along the bottom edge. Each sheet to be printed is butted up to these strips before printing.

Three strips of cardboard are attached to the baseboard to align each sheet of paper for each color printed.

Part One

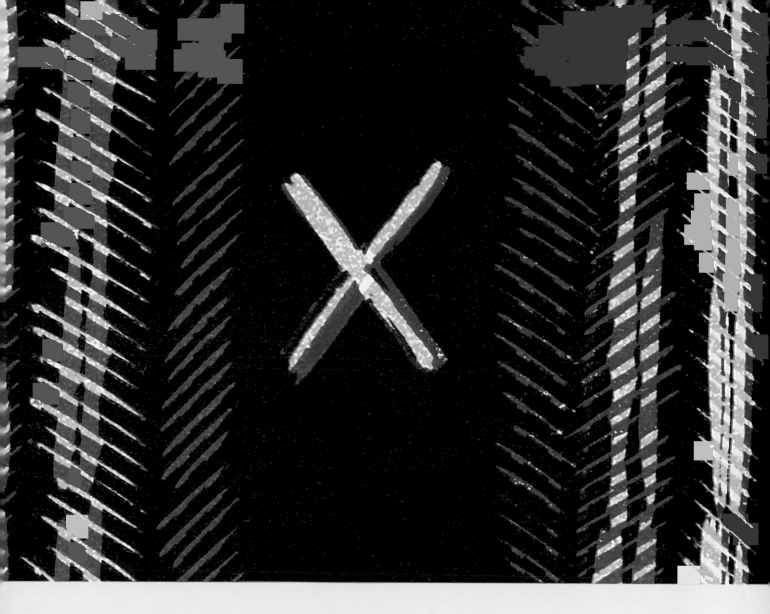

Basic Techniques

Linoleum Cuts (Linocuts)
Relief printing with linoleum

Tools and materials

You will need:
- Linoleum
- Permanent marker pen
- Bench hook
- Linoleum cutters (linocutters) (plastic or wooden handles, with choice of blades)
- Brayer (roller) for inking
- A suitable surface for rolling out the ink
- Palette knife
- Oil- or water-based inks
- Cleaning materials. Kerosene (white spirit) and rags (for oil-based inks), or sponge and water
- Paper. Select a paper with a smooth surface (important when printing by hand)
- Brayer (roller) for burnishing (or a press or baren)

Linoleum block and bench hook

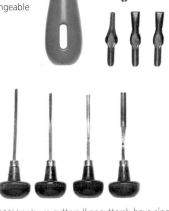

Plastic-handled linoleum cutters (linocutters): these are an economical choice, and have interchangeable blades.

Professional linoleum cutters (linocutters): have single blades fitted with a mushroom-shaped wooden end.

The linoleum cut technique is a relief printing process—a negative mark-making technique in which the material that is removed does not print. Areas of the linoleum block are cut away and the remaining raised surface is rolled with ink. This is covered with printing paper and hand burnished to produce the print; a press can also be used. Linoleum cuts are relatively inexpensive and, with a few safety guidelines, easy to produce at home.

The linoleum (lino) used for printmaking has no grain structure and a smooth surface making it easy to cut in any direction. It is an extremely approachable and direct medium for creating bold and vibrant images. Quality linoleum blocks are sold in various standard sizes from printmaking suppliers and are approximately ⅙ in (4.5mm) thick. The blocks are commonly brown or gray, with a fiber backing.

Mark making is carried out using metal gouges which vary from a flat blade through U-shaped scoops to fine-pointed V-cutters. The shape of the tool determines the amount and the shape of the cut and, in turn, the shape of the marks that are printed.

Although linoleum is traditionally printed using a press, it is straightforward to print by hand. This is done using a firm brayer (roller), as demonstrated in this example, or using a traditional Japanese woodcut tool known as a baren (a disc-shaped device made from bamboo). It is even known for printmakers to print using the back of a wooden spoon!

Making the first cuts

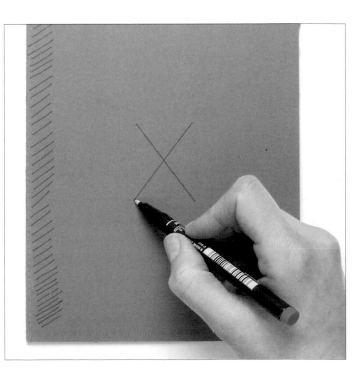

1 Mark out the basic design onto the lino surface using a permanent marker. The design can also be traced onto the block with carbon paper.

Multi-color images

One-color images are printed from a single block. More complicated designs may be printed from several blocks of the same size that have a design for each color cut into them, which are then printed one on top of the other. It is possible to produce a multi-colored image from a single piece of linoleum, however, using a technique called the reduction method.

The reduction method involves, first, cutting away the highlights (or any area that is to remain the color of the paper). All the sheets for the edition are then printed in the first color. More of the linoleum is cut away and printed with the second color. Cutting and printing continues until less and less of the original surface remains. It is a good idea when using this method to use a plan or sketch as a guide to the cutting and printing order. It is best to start with light colors and work toward the darker ones.

The reduction method has the advantage that the colors are easy to keep in register (see p.16) because they are printed from the same block.

Using the reduction method means deciding in advance how large the edition will be because there is no going back to print some more once the linoleum has been cut for the second time. Always print extra sheets since everybody makes mistakes! As a general rule allow at least 10% wastage for each color layer. So, if you wish to have an edition of 10 prints with three colors, then print at least 13 sheets of paper.

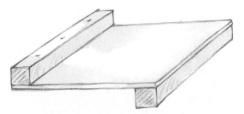

Making a bench hook

A bench hook is essential both in terms of safety and ease of cutting. It is simple to make yourself; all you need is a saw and a hammer. A bench hook consists of a flat piece of board to which two strips of wood are nailed. One strip is nailed to the underside which hooks against the edge of a table or workbench. The second strip is attached to the top of the board on the opposite edge; this forms a barrier to stop the lino slipping while it is being cut. Bench hooks can be made to any size, to suit the size of the linoleum block used.

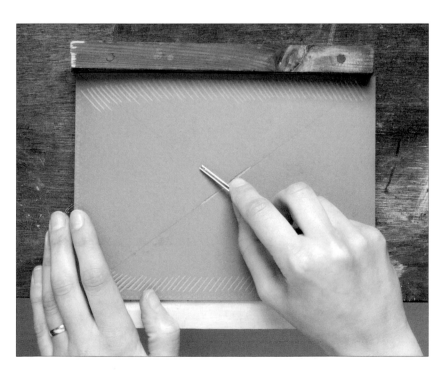

2 Tools are held with the bulbous end nestled into the palm of your hand, with the forefinger and thumb holding the shaft of the tool for precise control.

Cutting should always take place with the linoleum block positioned on the bench hook. Cut in a direction pushing away from the body. The hand holding the block must be behind the hand with the tool so that if it slips you will not cut yourself. To cut in a different direction, simply turn the linoleum block.

Cut away any area that will appear white (or the paper color) in the final design. The cutting depth will be determined partly by the tool used, but it is not necessary to cut deeper than half the depth of the linoleum. Lino is much easier to cut when it is warm; in cold weather gently warm the block against a heater before use.

Continued on next page

Printing the first color ink

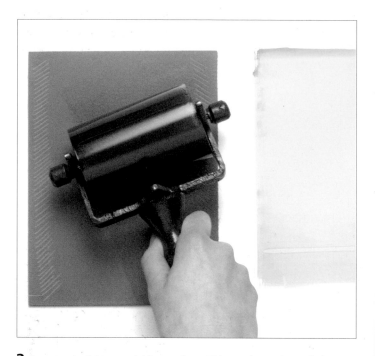

3 Prepare the ink on an inking surface. This can be a piece of plate glass or formica. Have a piece of glass around ¼–⅓ inch thick (5–8mm) cut to your size specification at a glass company, and have the edges beveled so that they are not sharp. Put the ink on the surface, mixing the colors if necessary, and working it over to soften it. Use a palette knife to spread the ink in a line to the width of your roller. Roll the ink into an even rectangle, and then ink the block.

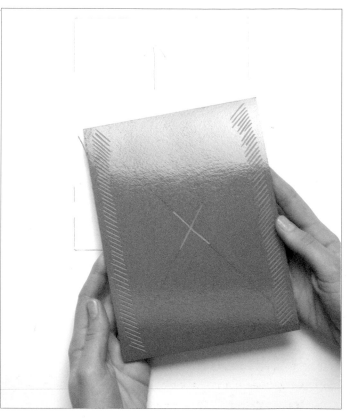

4 Mark out the backing sheet for positioning the linoleum block and the printing paper (for registration see p.16). Place the inked block face up onto the backing sheet, taking care to position it within the pencil marks. Place a sheet of printing paper over the block, carefully lining up the corners with those of the backing sheet.

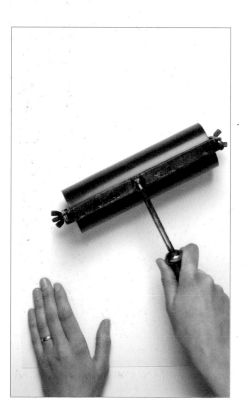

5 Holding the paper with one hand, use an uninked brayer (roller), pressing hard on the back of the paper. Roll in different directions.

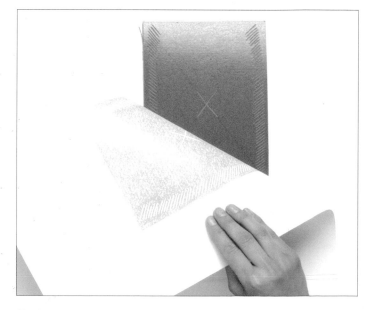

6 It is possible to see if the ink has been transferred properly by lifting the paper from one corner while keeping the other corner in place on the block with your other hand. If the ink has not transferred well, lower the paper and repeat the rolling.

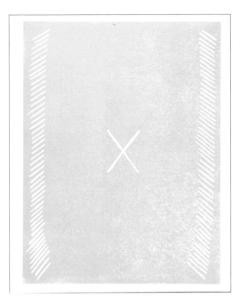

7 Yellow is used for the first color; only the central X and lines on the vertical edges have been cut away to reveal white paper. Once each sheet of paper is printed, clean the block, inking roller, and inking slab with a rag and kerosene (white spirit) for oil-based inks or a sponge and water for water-based inks.

The second color

8 Let the first printed color dry on all the sheets. Cut out areas of the linoleum block that you want to remain the first color, then ink the block in the second color (in this case red) and print on every sheet. Use the original backing sheet to guarantee good registration.

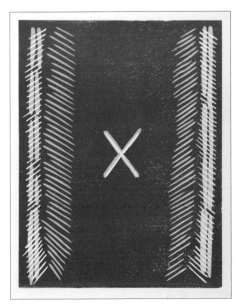

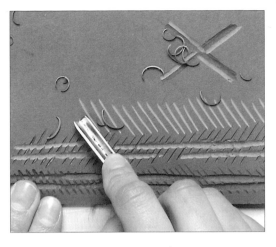

The third color

9 Clean the ink from the block, then reassess and decide what to cut from the linoleum next. Anything cut now will leave the first and second colors showing when the block is printed again. Vertical cuts are made on each side, followed by parallel diagonal cuts and a widening of the central X. Allow the sheets of paper to dry between printing each color.

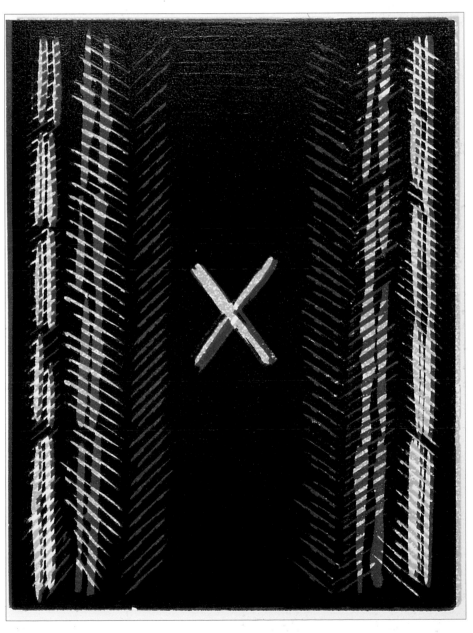

10 After further cuts have been made to the linoleum, a blue/black color is used for the final printing.

Gallery

"The Chrysler Building, New York," linoleum cut by Paul Catherall. While the reduction method was used for the building itself, an extra block was used for the blue sky.

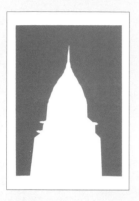

1 First the sky is printed using the second linoleum block.

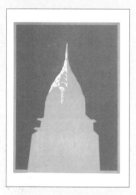

2 The white highlights and sky are cut out of the main block.

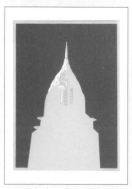

3 The gray shading at the top of the building is then cut out.

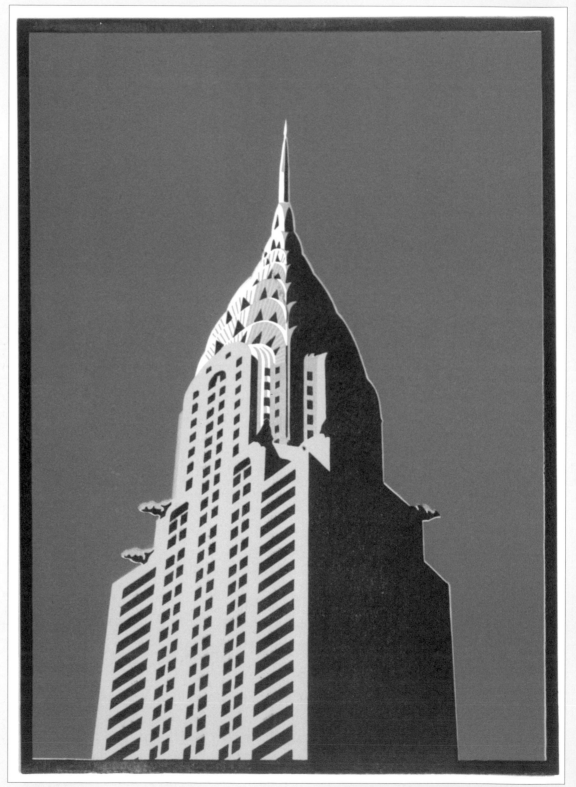

4 The block is then cut so that just the windows and shadows print when the final black ink is used.

Paula Cox, a one-color
linoleum cut.

Paul Catherall, reduction linoleum cut.

Anne Catherine Le Deunff, linoleum cut using two blocks.

Rubber Stamps
Relief printing with an eraser

Tools and materials

You will need:
- Erasers
- Ballpoint pen or soft pencil
- X-acto knife (scalpel)
- Engraving tools
- Brayer (roller) for inking
- A suitable surface for rolling ink on
- Palette knife
- Water-based relief printing inks
- Running water for rinsing
- Smooth paper

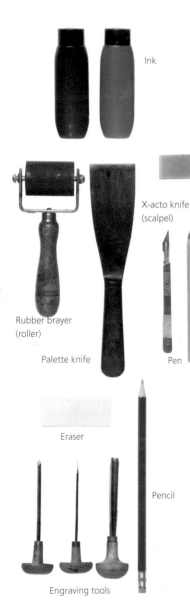

Ink

Rubber brayer (roller)

Palette knife

X-acto knife (scalpel)

Pen

Eraser

Pencil

Engraving tools

Like linoleum cuts (linocuts), rubber stamping is another form of relief printing. The attraction of the technique is that it is simple, approachable, inexpensive, and fun for artists of all ages. The stamp is cut from an ordinary pencil eraser. The only other things that are essential are cutting tools, ink, a roller, and some paper. Rubber stamps can be printed onto almost any surface, however, including textile and wood.

Your local stationery store will stock various brands of erasers, some of which are hard and others of which are soft. Buy a few different types to experiment with because the texture of some will be more satisfactory when cut than with others.

Choose water-based relief printing ink since it is the most convenient for cleaning up; the stamps can then be simply rinsed under running water to clean them at the end of the project.

Drawing a design

1 Start by drawing a design in pen or pencil, directly onto the eraser. Simple shapes are best. This is a "direct" printing process so the design will print in reverse, as a mirror image; this is particularly important to bear in mind if you wish to print numbers or letters.

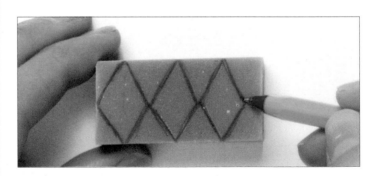

2 We used two types of erasers—the white one was very dense and firm; the brown kind was softer and had a crumbly texture. We drew a car on the white eraser.

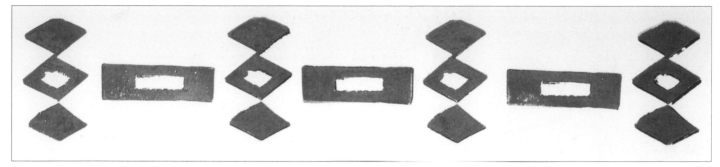

Frieze-like pattern made using two rubber stamps.

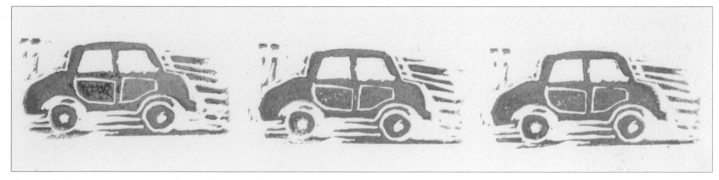

The car design was cut into a single pencil eraser, then multi-printed.

Cutting the stamps

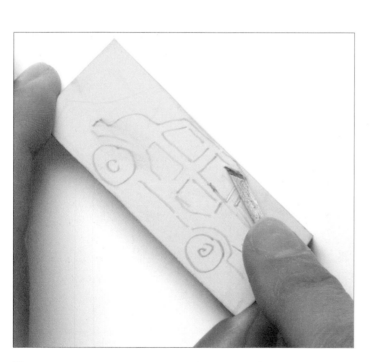

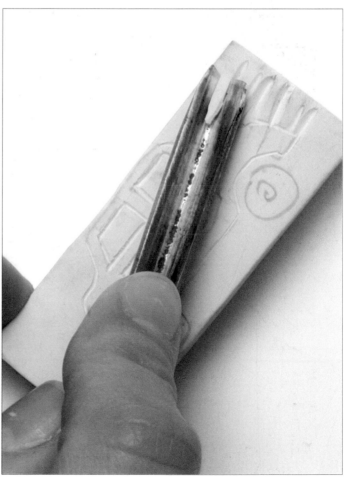

3 Cut out the car using a fine-pointed engraving tool for the details. When cutting, always remember to cut away from your body.

4 Use a larger gouge to scoop away the large areas of background that you do not want to appear when printed.

Continued on next page

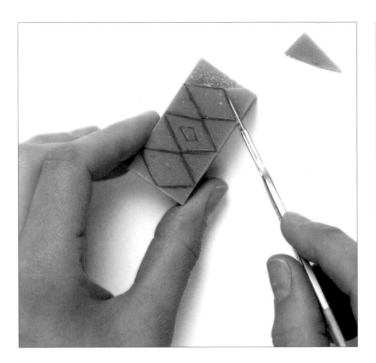

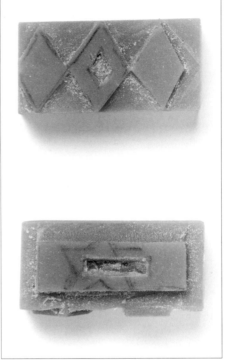

6 A second brown eraser was cut to make a complementary shape, which can be printed alongside the first to make a repeating design.

5 Straight lines on a stamp can be cut using a sharp X-acto knife (scalpel). Cut lines to half the depth of the eraser.

Making the print

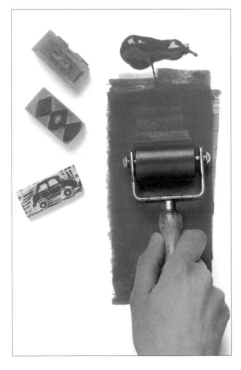

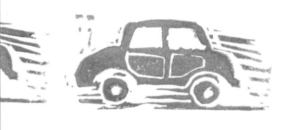

7 Roll the ink into an even slab of color (using the same technique used for linoleum cuts (linocuts), see p.22).

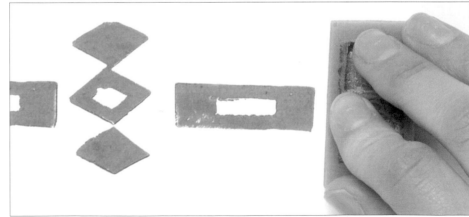

8 Simply roll the ink onto the eraser and press it firmly down onto the paper.

Gallery

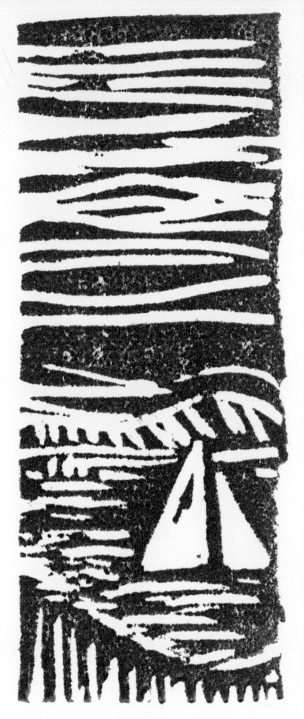

Rubber stamp by
Megan Fishpool.

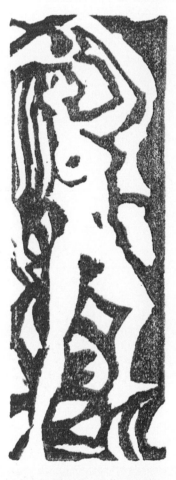

Rubber stamp by Simon Whittle.

Rubber stamp
by Meg Dutton.

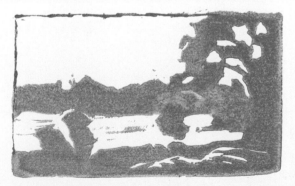

Rubber stamp by Melvyn Petterson.

Polystyrene Tiles
Relief printing with white foam

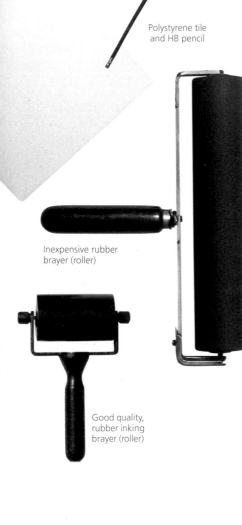

Polystyrene tile
and HB pencil

Inexpensive rubber
brayer (roller)

Good quality,
rubber inking
brayer (roller)

This is another simple relief printing method, but this time the printing block is made out of thin polystyrene. Printing blocks are made specifically for the production of fine-art prints and are available from good art and craft stores. The polystyrene tile used in this project has a very fine-grained surface which can be cut cleanly, however, a polystyrene tile will give an overall stipple effect to the print. This can be visually very pleasing and is worth bearing in mind when planning your design. With the exception of the tile and two brayers (rollers), no special equipment is needed to create a print. Even the printing is done by hand, burnishing the print paper from behind.

It is possible to create a multi-color print using this method but, given the simplicity of the approach, the best effects are usually achieved in a single-color print. In the example shown, a warm brown ink mixed from black, brown, and red has been used on a sympathetic cream paper. For all printmaking projects before you begin preparing the plate, first of all, cut all the printing paper you will require into a standard size. The size of the printing paper should be equivalent to the size of the tile plus a generous border all round.

Preparing the tile

1 A simple still life, inviting to the broad approach of this printmaking method, was arranged, which could then be sketched directly onto the tile. This was first loosely sketched onto a spare piece of paper to determine the composition. Here, a very simple, almost abstract style was employed. Begin working on the tile by lightly drawing the outlines of the objects with the pencil. This will leave faintly discernible marks on the tile's surface. Forcibly pierce the tile with the pencil at key points these will act as guides to further drawing.

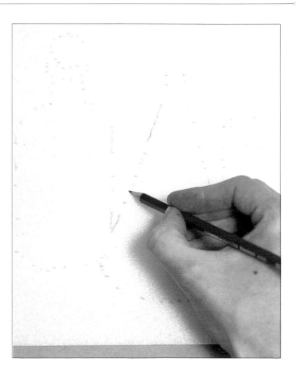

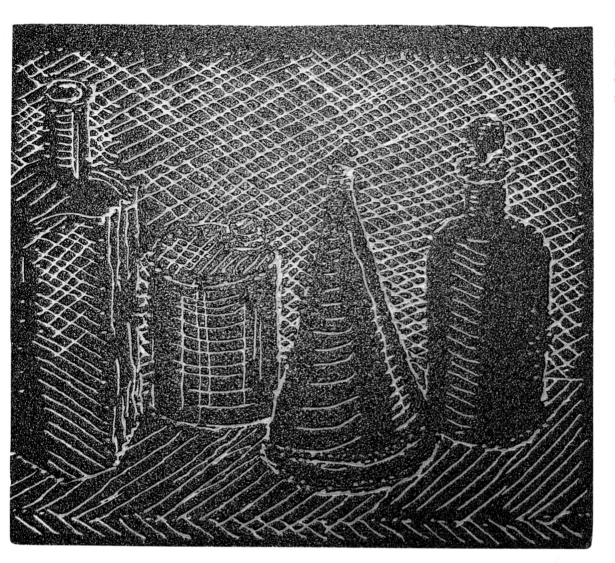

Polystyrene tile relief print in sepia ink on buff, colored smooth paper.

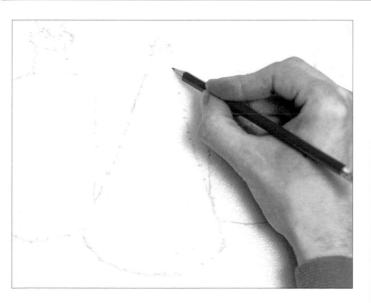

2 With a firmer pressure on the pencil, work round the outlines, "joining up the dots," and giving a deeper impressed line. The main structure of the composition is now plotted onto the tile.

3 Still using the pencil, apply very broad crosshatching to the background—making a bold pattern of widely diagonal strokes at approximately 45° to the edges of the tile. Add similar broad hatching to the table, but only in one direction to distinguish it from the background.

Continued on next page

4 Add bold, linear shading to the right-hand sides of the objects. The composition now begins to take shape.

5 Now add detail to all four objects in the composition using a combination of short lines and simple stippled dots.

Making the print

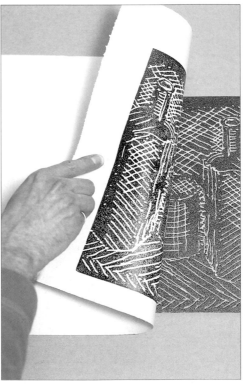

6 Prepare the ink (as with linoleum cuts, see p.26). Using a brayer (roller), ink up the tile with the mixed sepia color. Work backward and forward over the whole tile to give a consistently even film of ink over the whole surface.

7 Place the inked tile, face up, onto a clean and level work surface. Carefully place the printing paper over it, keeping the tile beneath it as centered as possible—the plain margins around the print can be evened off afterward, but the closer you are to a symmetrically-placed image the better. With the broad, clean roller, work thoroughly over the back of the paper making sure that the tile beneath does not slip.

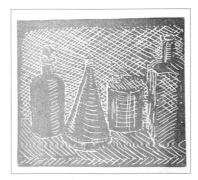

8 Peel back a corner of the paper very carefully to see whether the required density of ink has been transferred to the paper. If not, drop the paper back into place and apply more pressure with the brayer (roller). When the image has been satisfactorily transferred, carefully remove the paper from the tile and hang up to dry.

Gallery

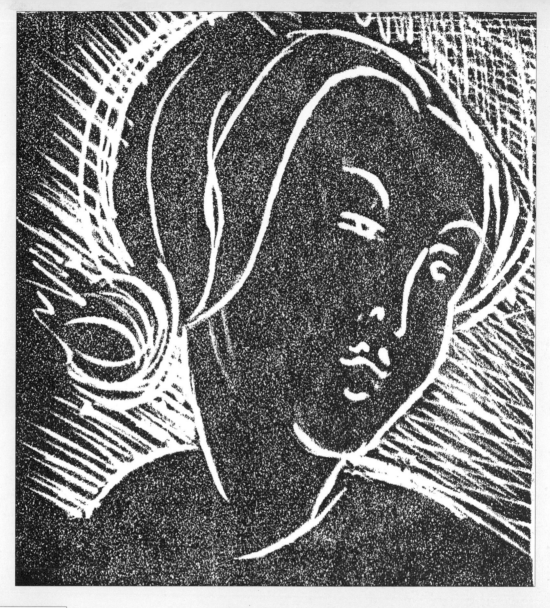

Poly tile relief by Megan Fishpool.

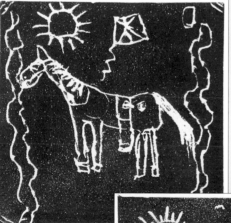

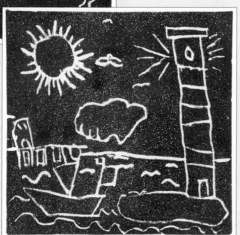

Relief prints by 7 year old pupils from Coleridge School, Rotherham, England.

Relief print by a pupil from Aylwin Girls School, London, England, aged 14.

Vegetable Prints
Patterns with potatoes and carrots

Tools and materials

You will need:
- Two carrots and a potato
- Sharp kitchen knife
- Linoleum cutting tools
- Paper towels
- Brayer (roller) for inking
- Suitable surface for rolling out the ink (see p.22)
- Blue and green relief printing inks
- Q-tip (cotton bud)
- Printing paper

The first experience in printmaking for many people is likely to be the potato print. However simple a method, the humble potato print encompasses many of the basic principles of more complex printmaking techniques: the creation of a printmaking matrix (a block), negative cutting (what is cut doesn't print), surface inking, and printing multiple impressions. The method teaches people printmaking is fun.

Tips

- Before cutting it is a good idea to draw the image onto the vegetable surface as a guide. Use an old ballpoint pen or a blunt metal object, such as a meat skewer.

- Try making multiple prints on large sheets of paper. Several vegetables can be used together to make up scenes or abstract patterns.

- Investigate other vegetables, such as turnips or rutabagas (swede), to find new shapes and textures; broccoli cut in two can produce beautiful tree-like images.

Carrots

Potato

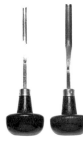

Professional linoleum cutters (linocutters): these have single blades fitted with a mushroom-shaped wooden end.

Rubber brayer (roller)

Relief prints from cut potatoes.

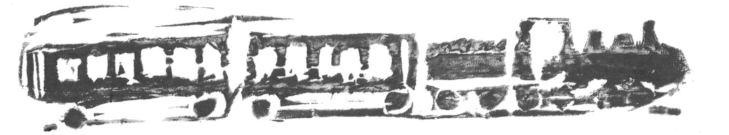

Relief prints from cut carrots.

Cutting the vegetables

1 Cut the potato and carrots in two, using a sharp kitchen knife. Make the cut as flat and as even as possible to provide a good printing surface. The shape of the vegetables themselves can suggest certain images. The carrots suggested a train or abstract leaf shapes, and the potato... Mr. Potato Head, of course! The images or patterns are cut into the vegetables using two shapes of linoleum cutting tools. The V-shape for detail, the U-shape for gouging larger areas.

2 Once the vegetables are cut, the surface is still very juicy. Soak up the liquid using paper towels and let the vegetables dry. It will not be possible to ink the surfaces properly unless they are completely dry.

Continued on next page

Printing

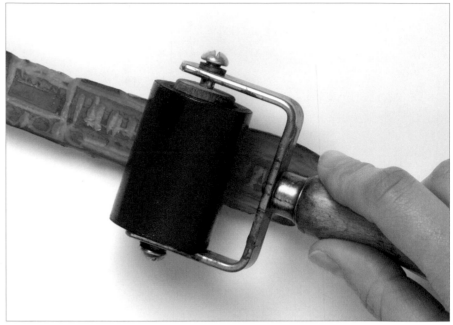

3 Prepare the inks by mixing the required colors and rolling them out flat, onto a smooth surface. Water-based or oil-based relief inks may be used.

4 Cover the surface of the vegetable with ink using a brayer (roller).

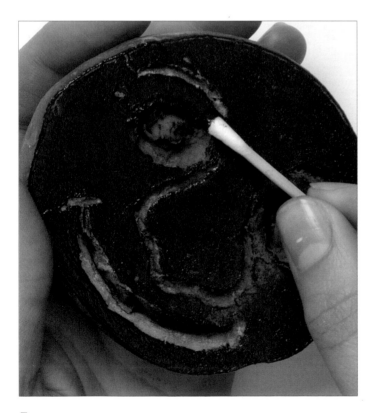

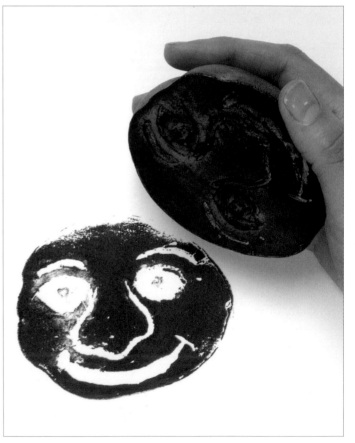

5 If small areas of the surface fail to ink properly, touch them in with a Q-tip (cotton bud) dipped in the ink.

6 Take the inked vegetable and press it down firmly onto paper. Rock the vegetable firmly with your hand to guarantee a good result.

Gallery

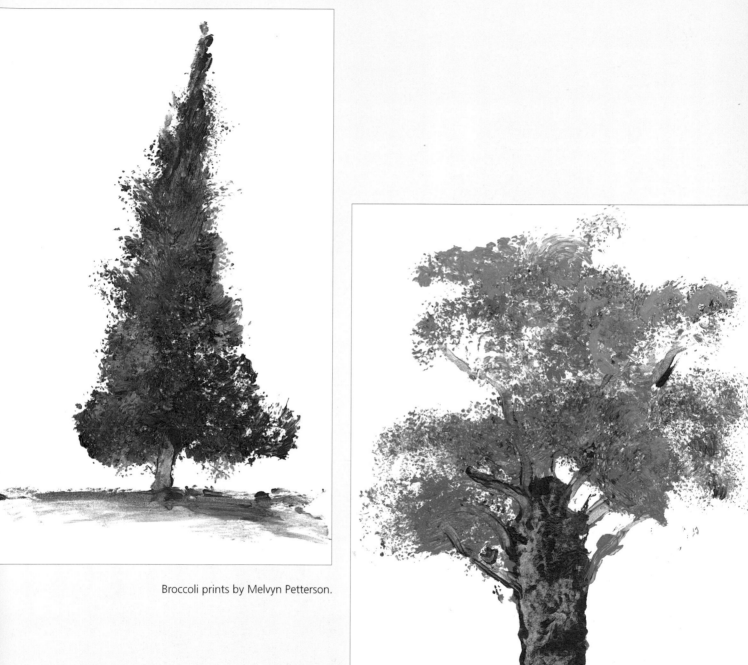

Broccoli prints by Melvyn Petterson.

Oven-Bake Modeling Clay
Relief printing

You will need:
- Package of white oven-bake modeling clay
- Rolling pin
- Kitchen knife
- Cookie (pastry) cutters (ship and star shapes)
- Wooden fluted pastry wheel
- Plastic fork
- Baking sheet (tray)
- Oven
- Soft rubber brayers (rollers)
- Suitable surface for rolling ink on (see p.26)
- Blue printing ink (mixed from blue and white)
- Off-white printing rag paper

White oven-bake modeling clay

Rolling pin

Shaped cookie (pastry) cutters

Oven-bake modeling clay can be formed into shapes and baked hard in the oven. It is also a versatile material to make a relief print with. Simply roll the clay out flat, cut out the size of plate you require, then press textures into the surface to create an image. After it has baked, the clay is rolled with ink and hand printed.

This is a basic way of printing, yet with enthusiasm and a little care, impressive results can be achieved. The only printmaking equipment needed is two rollers, water-based block printing ink, and paper. The cutters ideal for making marks on the clay are the ones used for cookie (pastry) dough, and can be found in most kitchens.

Once you have created a pattern in the soft clay, carefully follow the baking instructions on the clay package for oven cooking temperatures. The clay must not be baked longer than the prescribed time or it will begin to burn and give off fumes. When the clay has been removed from the oven, it will have hardened, and it may also have discolored slightly. This will not affect the printing. Before printing allow the clay to cool down properly, to complete the hardening process.

Opposite: A relief print made using kitchen utensils on oven-bake clay.

Preparing the clay

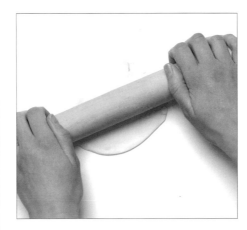

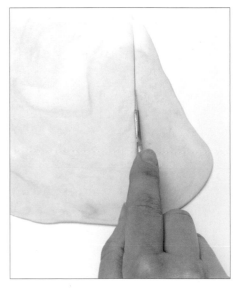

1 Cut a portion of the white clay and knead by hand until it is soft and pliable. Using the rolling pin, roll the clay flat so that it is at least ⅛ in (4mm) thick.

2 Use a kitchen knife to cut a 5 x 4 in (127 x 102mm) rectangle to form the image area.

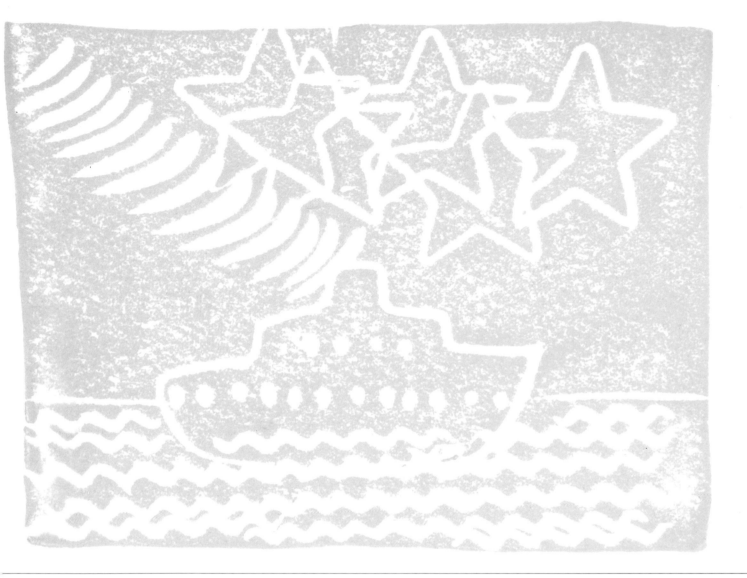

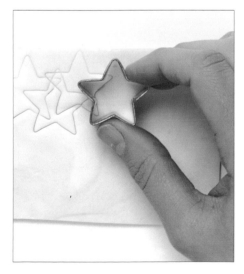

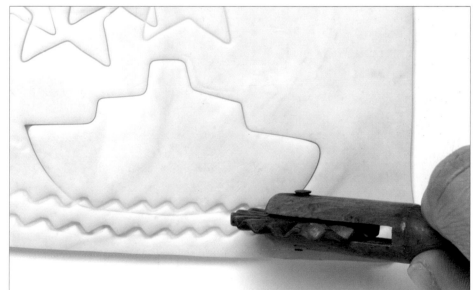

3 Press the star-shaped cookie (pastry) cutter into the sky area. The shapes only need to be pressed into the surface of the clay, not all the way through it.

4 Add the outline of the ship using a cookie (pastry) cutter, then roll the decorative pastry wheel into the clay to make wave patterns.

Continued on next page

5 Add two rows of port holes to the side of the ship using a plastic fork.

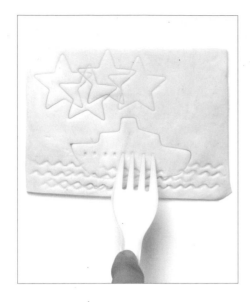

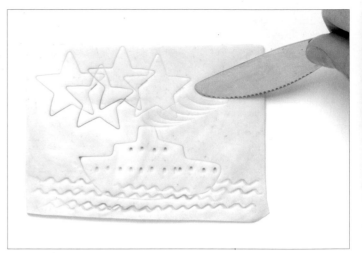

6 Use the knife to create smoke billowing from the ship's chimney.

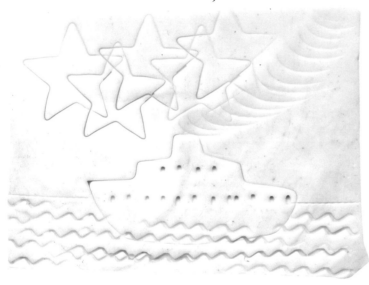

7 The completed design is now ready for baking. The clay is still very soft so handle it carefully at this point. Place the clay on a baking sheet and bake it in the oven for 30 minutes or as recommended on the manufacturer's instructions. After it has baked, leave it to cool and harden.

Tips

■ **Immediately after baking, the clay plate can be drawn into—use a sharp point at this stage to create extra lines and patterns.**

■ **Try to be as creative as you can when looking for objects to make marks with. A whole array of household objects and tools can be utilized.**

Making the print

8 Mix a light blue ink and apply to the surface of the block using a rubber brayer (roller). Make sure the surface is evenly but thinly inked, and that the ink doesn't fill the indentations, other-wise these will not show the white of the paper.

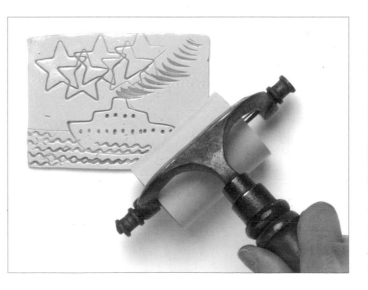

9 Lay a sheet of paper over the inked clay block. Roll over the back of the paper with a soft uninked brayer (roller). Lift corner to check that enough ink has been transferred.

Gallery

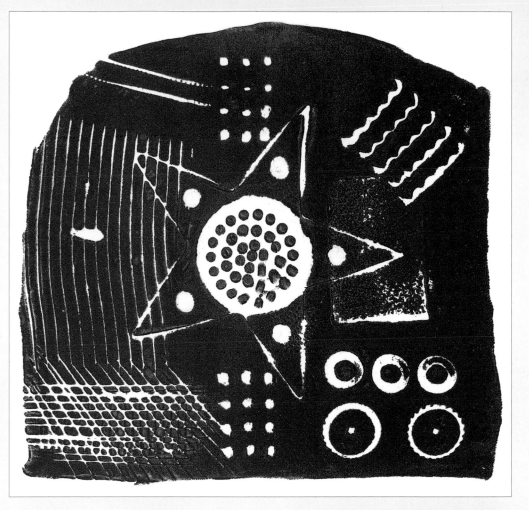

Melvyn Petterson, using kitchen utensils.

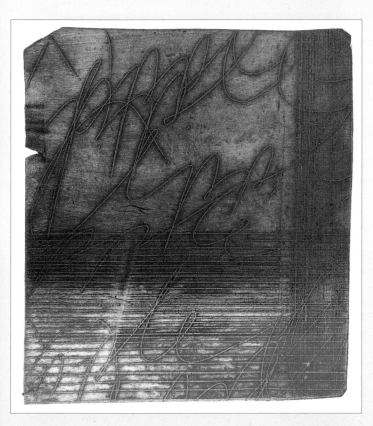

Megan Fishpool, using a dry point needle, printed in two colors.

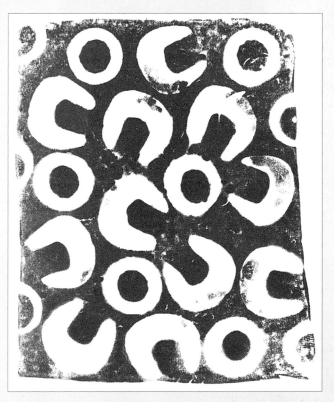

Colin Gale, made with a spanner.

Cast Etching
Printing using plaster of Paris

Tools and materials

You will need:
- An intaglio plate
- Pencil
- Hardboard base
- Heavy-duty mat (craft) knife
- 4 strips of wood
- 4 small nails
- Hammer
- Saw
- Oil-based ink
- Squares of matboard
- Tarlatan pad (scrim)
- Plaster of Paris
- Mixing container
- Water
- Large spoon

Etched plate

Saw

Hammer

Tartalan (scrim)

Matboard squares

Oil-based ink

Large spoon

Plaster of Paris

A cast etching is where a single plaster cast is taken from an etching or another form of intaglio plate. Many forms of printmaking include an element of sculpture—since the block embosses the paper creating contours in the textured surface as well as transferring ink. Cast etching takes this idea of sculpture further by using a medium that creates a perfect mold for the original—extending the feeling of object and dimensionality. Ink is often used (as with this project) to help accentuate the lines. Plates are inked in the usual way using oil based inks, any color may be used. The result is both a print and a sculpture at the same time, an object for decorative purposes. The process is capable of holding the most subtle of details and marks. The finished tile may be displayed or box framed. Many tiles from the same plate may be individually cast, these can be sealed with clear water based varnish and cemented to a wall to form a tiled frieze.

You will need a completed intaglio plate for this process—cast etchings can be made using etchings, engravings, dry points, and mezzotints. The process will not harm the plate in any way. Any number of casts can be made with no wear to the plate surface. For this process there is the distinct advantage that a press is not required. All materials are easily found at a well-stocked hardware or art supply store. The plaster itself is sold under various names such as modeling plaster or plaster of Paris.

Making the mold

1 Make a box consisting of a hardboard base with four strips of thin wood that are approximately 1 in (2.5cm) in height. Place your intaglio plate onto the board and draw around it with a pencil. Cut this out with a heavy duty mat (craft) knife using a straight edge as a guide.

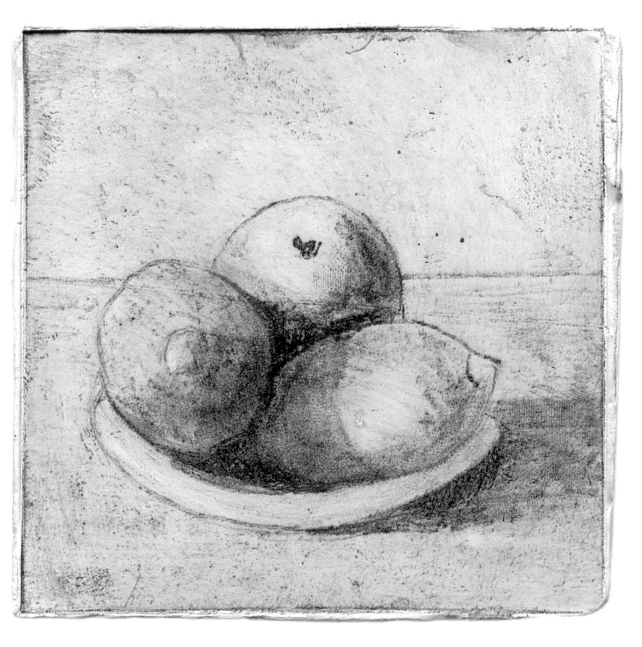

Final plaster cast taken from an etched plate by Sheila Yorke.

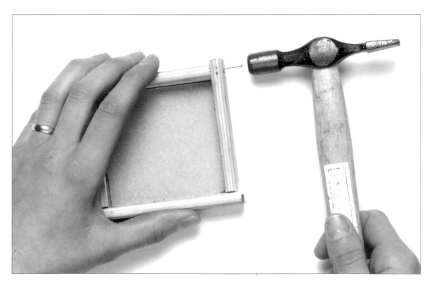

2 Then cut four strips from the thin wood. The lengths must be longer than the dimensions of your base to allow an overlap for joining the strips together. Position the strips around the base so that they are flush with the edges of the base. Fasten the first two strips together at the corner by hammering in a small nail. It is much easier if someone holds the strips together for you while you hammer. Work your way around until all the strips are joined. The wooden base should now fit snugly between the strips but is not actually fastened to the sides since it will need to be pushed out when the casting is completed.

Continued on next page

Inking the plate

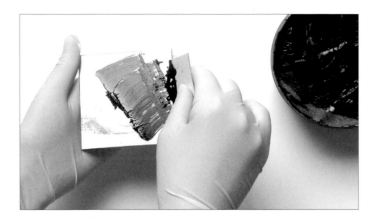

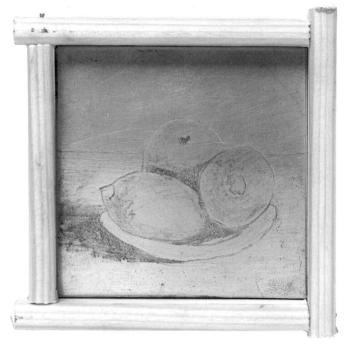

3 Place the oil-based ink directly onto the plate surface. Spread the ink over the entire plate surface using a square of matboard, pushing the ink down into the depressions. Wipe the plate gently with a pad of tarlatan (a rough cheesecloth or muslin, also known as scrim), so that the ink only remains in the furrows. The ink will also act as a lubricant which will help release the cast once the plaster has set.

4 Place the inked plate face up at the bottom of the wooden mold.

Mixing the plaster

5 Mix the plaster with water to a creamy consistency. Beginning at one corner, slowly pour the plaster into the mold. Allow the plaster to flow across the plate to make sure that no air bubbles are trapped. The final depth of plaster should be between ½ to 1 inch (15–25mm). Smooth the surface with the back of a spoon and let it set for about an hour. It is normal for the plaster to heat up during the setting process.

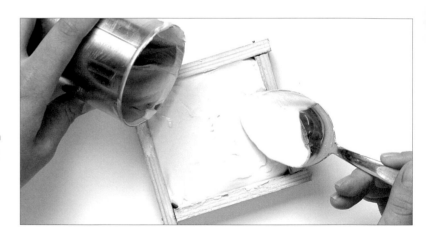

Turning out the mold

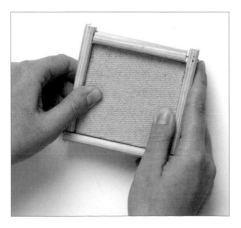

6 Turn the mold upside down. Push the hardboard with your thumbs to release the cast. The whole process may be repeated as many times as you wish, with no risk of wearing out the plate. Experiment with different colored inks to produce variations.

Blind printing

It is possible to make a cast of an etched or engraved plate without ink. This is referred to as blind printing or embossing, and creates relief marks in virgin plaster. The technique is the same, but instead of using ink, lightly rub the plate surface with a small amount of mineral oil using a clean rag. This will lubricate the cast allowing it to free easily when set. When casting a collagraph plate (see p.104), make sure the surface is sealed with varnish.

Gallery

A copper plate inked
in two colors. The
red was inked
intaglio. The yellow
was surface rolled
using a hard rubber
brayer (roller).
By Megan Fishpool.

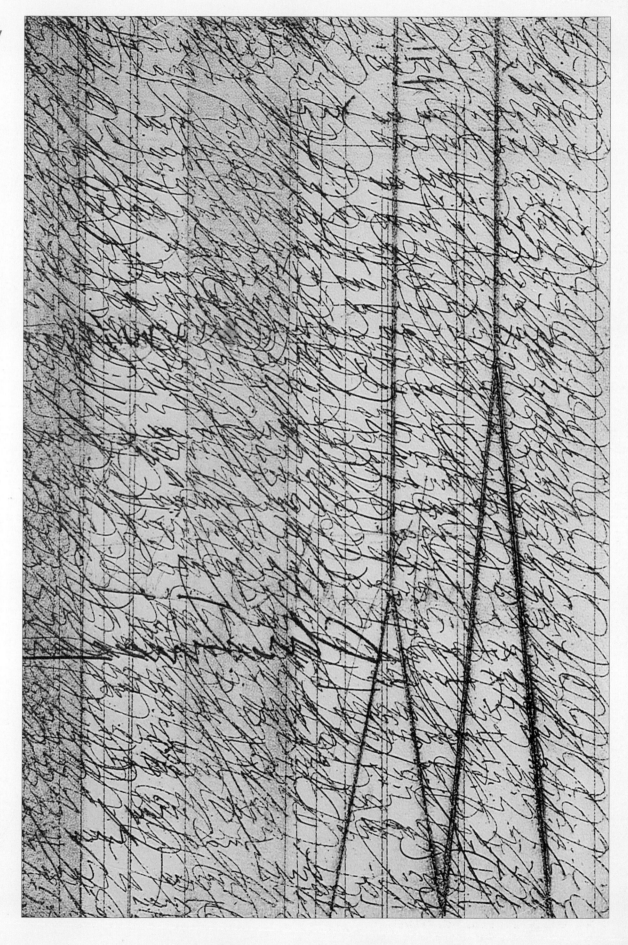

Woodcuts
Relief prints using carved wood

Woodcut is a simple and direct medium which can produce powerful images with unusual light and dark contrast. The technique traditionally uses lumber cut parallel to the plank, or side, grain of a tree trunk. Large woodcuts can be made on boards manufactured from compressed fibers or layers of plywood. In woodcut, unwanted areas of the wood surface are cut away. The remaining surface is inked using a brayer (roller). The block is printed with downward pressure by hand—or by using a letter press or other relief press (see p.10).

Choosing the wood

It is possible to make a woodcut on almost any flat piece of wood, which can vary greatly in hardness and grain structure. To begin wood cutting, we recommend using one of the manmade boards such as medium density fiberboard (MDF), hardboard, or plywood. These are all inexpensive, and small end-pieces can often be bought at very low cost from a lumber yard.

Fiberboard and hardboard are made from compressed fibers, therefore they have no grain structure and are easy to cut in any direction. Plywood is more unpredictable to cut since the grain tends to splinter. However, artists often use this to their advantage because the grain itself holds ink in a unique way. Plywood is especially effective when used on a large scale.

Tools and materials

You will need:
- 3/16 in (4mm) thick hardboard
- Heavy-duty mat (craft) knife
- Steel ruler
- HB pencil
- Bench hook
- Selection of cutting tools
- Varnish or shellac
- A suitable surface for rolling out the ink
- Putty (push) knife
- Ink brayer (roller)
- Black and red printing inks
- Thin, smooth paper
- Baren

3/16 in (4mm) hardboard

Selection of cutting tools

Starting the woodcut

1 Cut the hardboard to shape using a heavy duty mat (craft) knife and a steel ruler. Sketch the head and shoulders onto the hardboard using an HB pencil. When drawing the image, bear in mind that it will be reversed when printed.

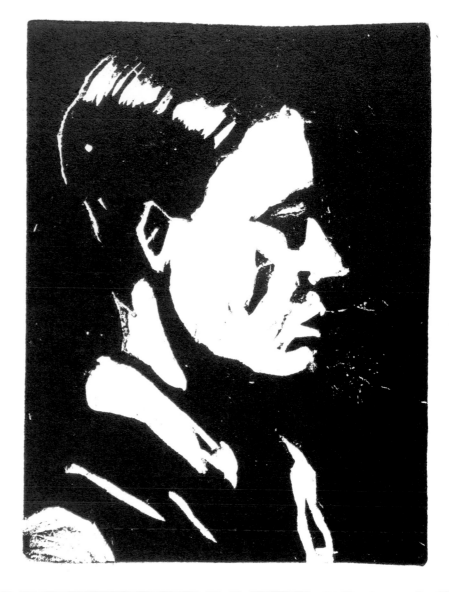

Cutting tools

A set of inexpensive woodcutting tools can be purchased from an art supply store. The tool blades are similar in shape to linoleum cutting tools. V shapes are used for cutting details and U-shaped gouges for general work, while chisels are used for clearing large areas. For safety, always use a bench hook when cutting a block (see p.25).

This woodcut, cut from a piece of hardboard, is based on a woodcut by William Nicolson.

2 Place the block on the bench hook for cutting. Using a broad cutter, cut away the larger areas. Remember that what you cut will not print but will show the paper.

3 Using a small V-shaped tool, cut away the more difficult detail areas until the image is at a point ready for inking. Use a variety of tools, allowing the varied cutting marks to show on the print. The marks used are often as exciting as the image itself.

Continued on next page

Printing the woodcut

> **Tip**
>
> Before printing, is is advisable to seal the wood with a thin coat of varnish or shellac to prevent the ink being absorbed into the wood.

4 A putty (push) knife is used to mix the ink. Here we have used a black ink warmed by the addition of a little red. Either oil-based or water-based relief inks may be used.

5 Roll the ink into an even film until the roller has taken enough ink to cover the block. Keep the ink thinly spread so that there is less chance of the detail being filled in on the block.

6 Roll the ink onto the block in different directions. Recharge the brayer (roller) with ink when necessary and continue rolling until the block is evenly covered.

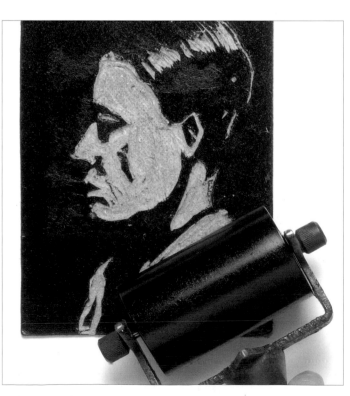

7 Lay a sheet of thin smooth paper over the woodcut block. Rub the back of the paper firmly using a baren—a traditional Japanese, disk-shaped tool that has been used for woodblock printing for centuries. Carefully pull back the paper to reveal the image.

Gallery

Woodcut in three colors printed on Japanese paper by Susan Short.

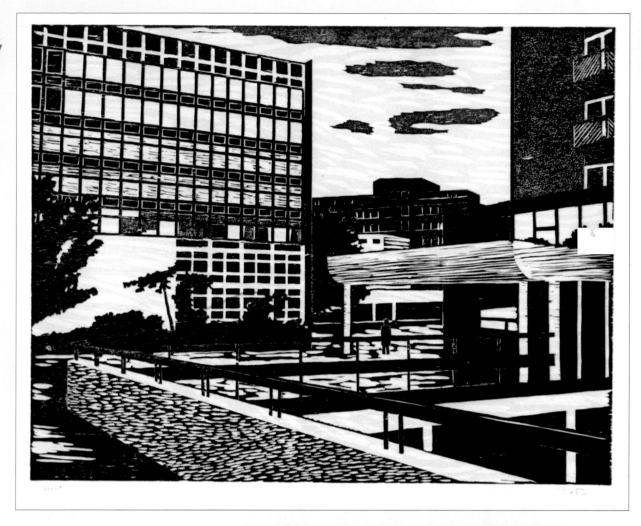

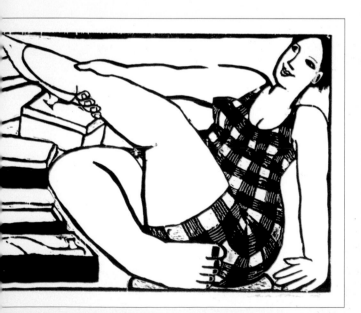

Woodcut by Anita Klein.

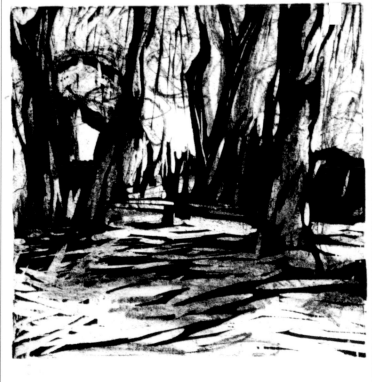

Woodcut from laminated pine by Rachel Gracey.

Boxwood Engraving
Scoring an image on dense timber

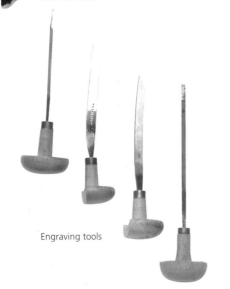
Sandbag

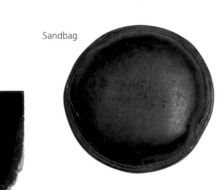
Boxwood block

Engraving tools

Wood engraving, unlike woodcut, uses the cross grain of a tree. Cutting across the trunk gives a much denser piece of wood, allowing finer cutting and engraving. Boxwood is traditionally used but it is expensive. Boxwood doesn't grow very large, and this explains why boxwood engravings are made on such a small scale. It is rare to have a boxwood block wider than three inches (75mm). Larger blocks can be made by gluing blocks together, however this is not an easy job to do at home and should be left to a professional. Holly, cherry, and pear are cheaper alternatives to boxwood.

Wood blocks are traditionally printed on a relief press with downward pressure, and in the past would have been set with type to form a page of illustrated text. Old relief presses are difficult to find; they are very heavy and require a moving company to move. They also have antique value due to their cast features, such as lion's feet, making them an expensive acquisition. A letter (nipping) press (see p.10), is a solid cast screw press, designed for use in bookbinding. The press used in our example was purchased very cheaply from a secondhand shop.

Making a test strip

1 To hold an engraving tool, place the curved edge of the wooden mushroom into the palm of your hand. The thumb and forefinger should grip the shaft near the point and the remaining fingers should rest along the shaft. The tool is pushed by the palm and thumb muscle while being steadied and guided by the thumb and forefinger.

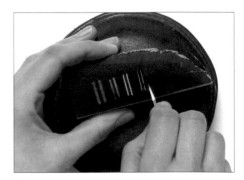

2 The first step is to paint the block with a coat of black India ink using a soft brush. This enables you to see the cuts for this relief printing technique more easily, revealing the light-colored wood in strong contrast as cuts are made in the black surface. Here a test piece is being engraved to show the types of straight lines possible with a graver.

Engraving tools

Engraving tools are designed to be used as parallel to the wood surface as possible, to avoid digging into the wood—that is why there is a flat, cutaway side to the mushroom-shaped handle.

Engraving tools are made in different widths and shapes, known as gravers, spitstickers, and scorpers. A graver, or burin, has a lozenge-shaped point which is used for straight lines. A spitsticker has a rounded point that is used for curves. Scorpers and small chisels gouge larger sections.

Boxwood engraving printed in black by Erika Turner-Gale.

3 Using different width tools, textures are built up with cross-hatching. In this illustration the two bottom strips were made using the multiple lining tool. Note the shape of the boxwood block, which has been cut from the outside curve of the tree trunk.

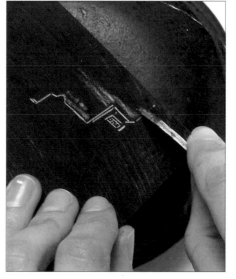

4 Outline the shape of the building with a graver, then, with a scorper, gouge out the sky areas immediately behind the building.

Engraving the block

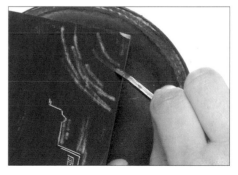

5 Cutting takes place on a leather sand-filled bag. This allows the block to be turned as it is cut. To cut a curve, the spitsticker is pushed forward and the block is turned, forming the curve. A substitute for a sandbag may be fashioned from a heavy book tightly wrapped with fabric.

Continued on next page

Printing a wood engraving

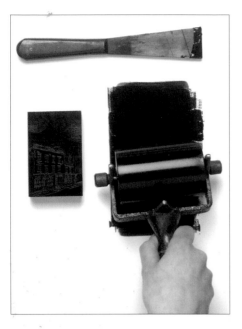

6 Begin by spreading a line of ink with a putty (push) knife onto the inking surface of glass or formica. Roll the ink thinly into a rectangle, then roll the block evenly with ink.

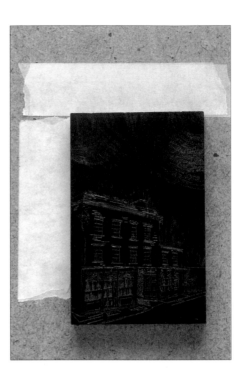

7 To print using a letter (nipping) press, cut a thin sheet of wood or matboard to act as a base, which will allow you to slide the block in and out of the letter (nipping) press. The block is registered centrally on the base using strips of masking tape. The base also acts as a guide for placing the paper on the inked block.

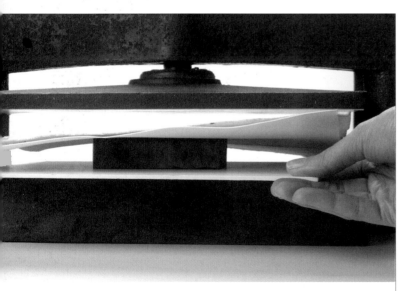

8 Choose printing paper with a smooth surface (see p.14), and place a sheet of it over the block. A piece of felt blanket or several sheets of blotting paper are placed on top to act as packing to distribute the pressure evenly. This "sandwich" is then carefully guided into the letter (nipping) press.

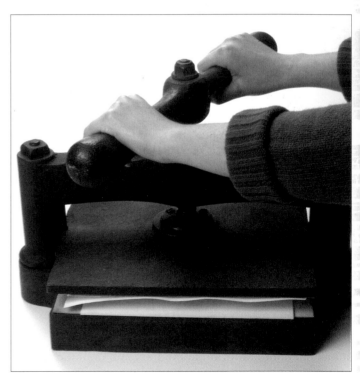

9 Make sure the block is roughly in the center of the press and begin turning the screw to administer pressure. The screw must be turned until it is very tight. Release the pressure by unscrewing the platen to its highest position. Remove the "sandwich" holding the baseboard alone. Take off the packing and peel back the paper. Further prints are taken by re-inking the block and repeating the printing process.

Gallery

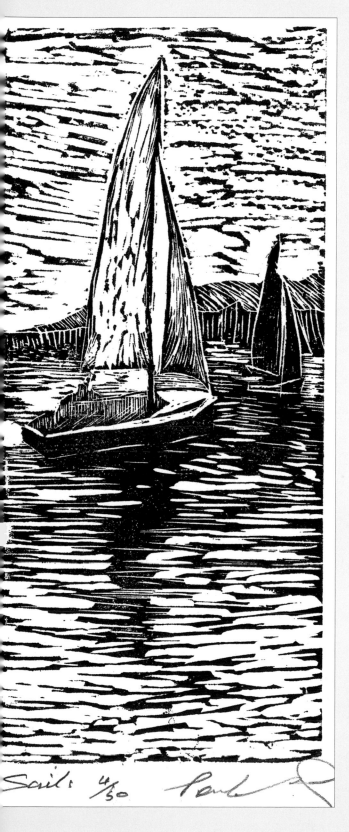

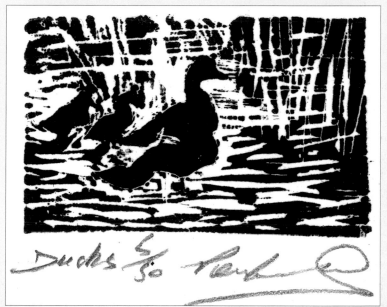

Wood engraving by Paula Vokes.

Wood engraving by Paula Vokes.

Screenprinting
Using paper stencils and screen fillers

Although it has a huge number of commercial applications, screenprinting can be enjoyed at home with a few pieces of inexpensive equipment. It is essentially a stencilling process. The screen itself is a fine evenly-tensioned mesh which is stretched over a wooden or aluminum frame. Parts of the screen are then masked using paper or filler to make the design. Ink is then spread on the screen and pushed through the open areas of mesh to the paper (or other material) below.

Screenprinting suppliers sell ready-made machine-stretched screens in standard sizes, and will make custom-made sizes to order. Mesh is supplied in various gauges. For paper printing, we recommend 12xx (90t) as a good all-round performer, and 16xx (120t or 150t) for finer work. The finer the mesh the more delicate and easier it is to damage.

A professional studio or university art department will have screen printing tables, where the screen is clamped in place and is lifted by a counterweight. For printing at home or in the classroom you can make a simple baseboard to act as a printing table. The screen is hinged to the baseboard so that it can be lifted up and down.

Opposite: Water-based screenprint of marsh marigold using four hand-cut stencils and one painted line stencil.

Tools and materials

You will need:
- Sketching paper
- HB pencil
- Waxed (greaseproof) paper
- X-acto knife (scalpel)
- Cutting mat
- Screen and baseboard
- Polyester screen tape
- Masking tape
- Acrylic paints
- Jelly (jam) jars
- Plastic palette knives
- Printing medium
- Printing paper
- Bucket of water
- Sponge
- Old newspapers
- Spray bottle of household cleaner
- Squares of matboard
- Spoon
- Squeegee
- Clear gum and screen filler
- Fine sable brush

Screen and squeegee

Waxed (greaseproof) paper

Plastic palette knives

Printing medium

Acrylic paint

Jelly (jam) jars

Making the first stencil

1 Sketch the key image areas in pencil to the required printing size. Color swatches are made to work out how many colors are to be used and the printing order. In screenprinting, colors are printed one at a time so that the image is built up in separate layers. A separate stencil is cut for each color, usually working from light to dark colors.

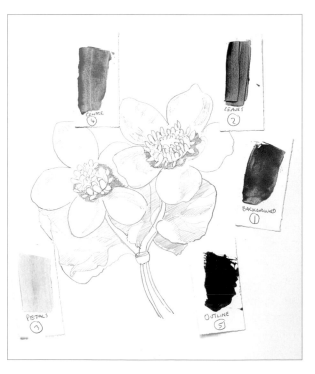

Squeegees, stencils, and inks

A squeegee, consisting of a rubber blade with a wooden handle, is used to push the ink through the mesh. Squeegees come in different lengths, to suit the dimensions of the screen being used. For paper stencils, use ordinary waxed (greaseproof) paper from the supermarket. It has the advantages of being both water resistant and transparent so can be used to trace designs.

Different types of water-based inks can be used, but the clear base system is the most economical. Standard acrylic paints are mixed with a base to make printing ink. The base is a printing medium with no color; several different brands are available which all perform in a similar way. Mix the paint and base in jelly (jam) jars in roughly equal quantities; the exact proportions will vary with the desired transparency or opacity of the ink.

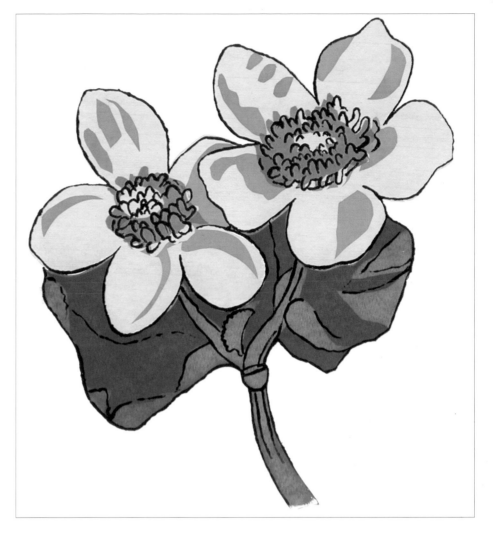

2 A sheet of waxed (greaseproof) paper is laid over the sketch. The shapes which are to be printed in the first color are traced with a pencil. The stencil is cut over a cutting mat with an X-acto knife (scalpel). The areas which are to print are carefully removed. Cardboard or a stack of newspapers can also be used as a cutting mat.

3 The stencil is now placed under the screen on the baseboard. The stencil must be large enough to wrap round the side of the screen frame. Attach the waxed (greaseproof) paper to the screen frame with masking tape. Use polyester screen tape to stop ink seeping between the mesh and the screen (described in detail in *Defining the image area* on pp. 60–61).

Continued on next page

Printing the first color

4 Make all the preparations before printing. Mix the required ink color (see p.58) making more than you think you need, since it is very inconvenient to run out before all your sheets of paper are printed. Prepare the printing paper by cutting to size the required number of sheets for the edition, plus some extra for mistakes. Have cleaning materials ready—a bucket of water, sponge, newspapers, and a household cleaner spray.

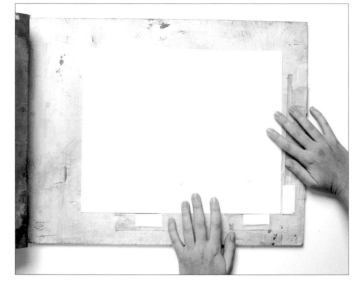

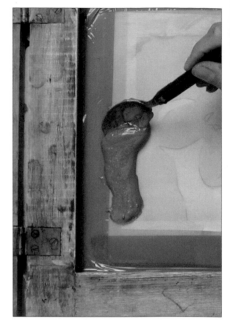

5 The first sheet of paper is registered onto the baseboard using three tabs of cardboard fastened down with masking tape. This is an important step—the ink must print precisely in the same position on each sheet of paper in order for the subsequent colors to line up. Place two tabs on the right-hand corner and a third along the leading edge. Butt up each sheet to these tabs prior to printing.

6 Spoon ink onto the side of the screen mesh.

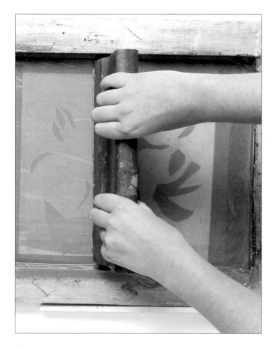

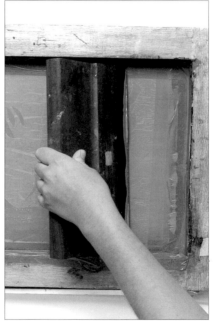

7 With the squeegee held at a 45-degree angle, pull the ink across the screen with firm pressure. This forces ink through the mesh, through the open stencil areas, and onto the paper.

8 Lift the screen slightly and remove the printed paper. With the screen still slightly lifted angle the squeegee the opposite way and push the ink back to the starting position. This is referred to as "flooding the screen."

9 To print the next sheet, support the screen in the raised position and place the next sheet of paper against the registration tabs. The printing action is repeated. All the sheets for the edition number required are printed in this way, plus extras to allow for mistakes. Place each sheet in a drying rack (see p.123). After all the sheets are printed start clearing up immediately. Return excess ink to the jar using a plastic palette knife. Remove and discard the paper stencil from under the screen. Place newspaper onto the baseboard and clean the screen thoroughly using the sponge and water. Household cleaner from a spray bottle, the sort used to wipe kitchen surfaces, is sprayed on the screen to help speed up the paint-removal process.

The four background colors

11 The second printing. Note how the first yellow ocher printing shows through the slightly transparent green, so that there are already three colors after only two printing stages.

10 The first printing stage. Second and subsequent colors are printed by cutting new stencils traced from the key sketch. The print is built up starting with the larger background areas and then finishing with the finer detail.

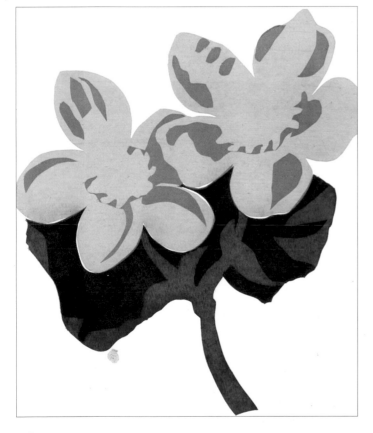

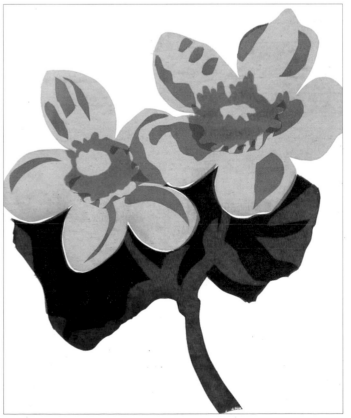

12 The third printing stage. A new color is added to form the petals of the marsh marigolds.

13 The fourth printing stage. The centers of the flowers are now added. The main color areas are now complete.

Continued on next page

Adding a keyline

14 To complete the study, a black keyline is needed. The master drawing is placed under the screen mesh. The screen is lifted slightly—place a jelly (jam) jar lid under one of the corners to do this.

15 Thin lines are too difficult to cut by hand from waxed (greaseproof) paper, so a gum-painting medium and screen filler are used instead. A clear gum solution is painted directly onto the screen mesh with a fine sable brush where the line is required; this is a positive working system, so that whatever is painted will print. The gum is left to dry.

16 Using a piece of matboard, wipe the filler thinly over the whole mesh. This will prevent ink from passing through it. When the filler has dried, the gum is washed away with a sponge and water. This leaves the mesh open wherever the gum solution was painted through which the ink can pass. The screen is taped with masking tape. A black ink is mixed for the final color. The nearly-completed print is placed under the screen. By looking through the filler stencil it is possible to move the print into the correct position. The paper is then registered in place with the three cardboard tabs before printing as in step 5, p.56.

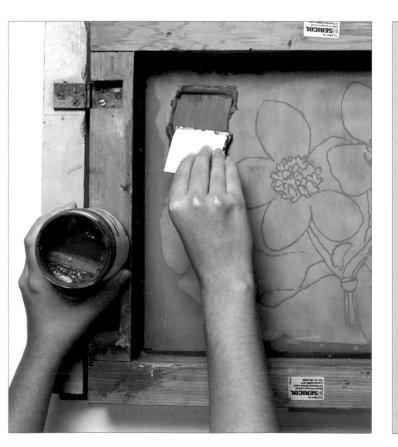

17 To remove the filler follow the manufacturer's instructions; this usually involves putting newspaper underneath the screen and clean using a sponge, hot water, and household cleaner. Screen filler becomes harder to remove the longer it is left on the screen—remove as soon as the image is completed. If the filler has hardened, use a high pressure hose (the type used for cleaning cars).

Gallery

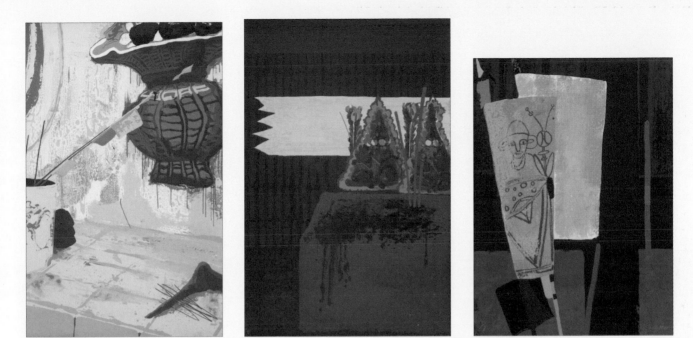

Filler stencil screenprints by Jo de Pear.

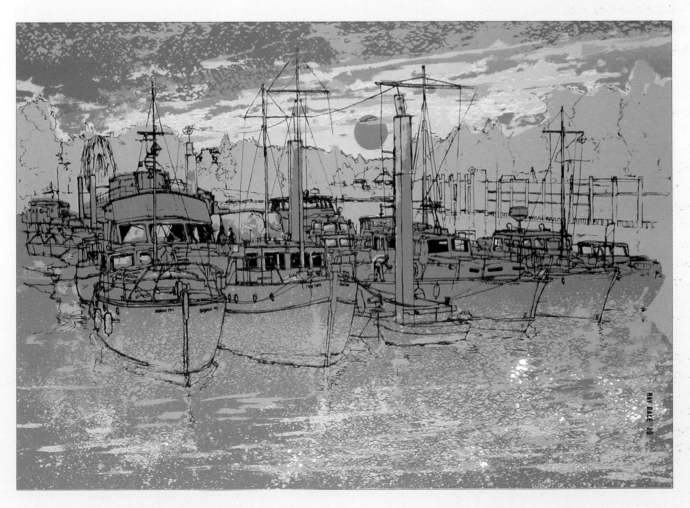

Screenprint with hand-cut paper stencils and line stencil by Ray Gale.

Monoprinting with a Screen
One-off screenprints

Tools and materials

You will need:
- Screen and baseboard
- Polyester screen tape
- Printing paper
- Squares of cardboard or matboard
- Various sizes of paintbrushes
- Plastic palette knives
- Acrylic paints
- Jelly (jam) jars
- Printing medium
- Spoon
- Squeegee
- Bucket of water
- Sponge
- Old newspapers
- Spray bottle of household cleaner

Squares of cardboard or matboard and a paintbrush

A selection of mixed inks

Printing medium

Monoprints, or monotypes, are one-off prints, where the image is made without the use of a plate, stencil, or block. Monoprints can be made using the screenprinting technique by painting or drawing directly onto the screen; this is then transferred, or printed, onto paper. Although with this technique, an edition (multiple copies of the same image) is not possible, you can produce many variations based on one pictorial theme, simply because the technique is so quick to execute.

Two similar methods are explained in this book; in this screen project, inks are painted on, while on p.64 the image is drawn using crayons. Both use standard screen printing equipment and non-toxic water-based materials. Painting with ink, described here, suits a loose gestural image, or an abstract composition.

Prepare the inks
Speed is of the essence with this method, to prevent ink drying in the mesh, so mix all the colors before you start. It is an ideal opportunity for using up previously mixed colors that you may have stored.

Opposite: Painted screen monoprint using water-based screen inks.

Defining the image area

1 Tape up the screen using polyester screen tape to define the image shape required. Cut a length of tape as long as the inside dimension of your screen. Place this strip half on the mesh and half on the inside of the frame. Smooth it down with your fingers.

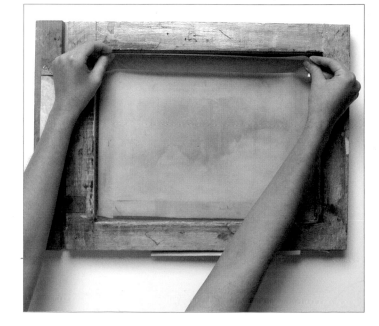

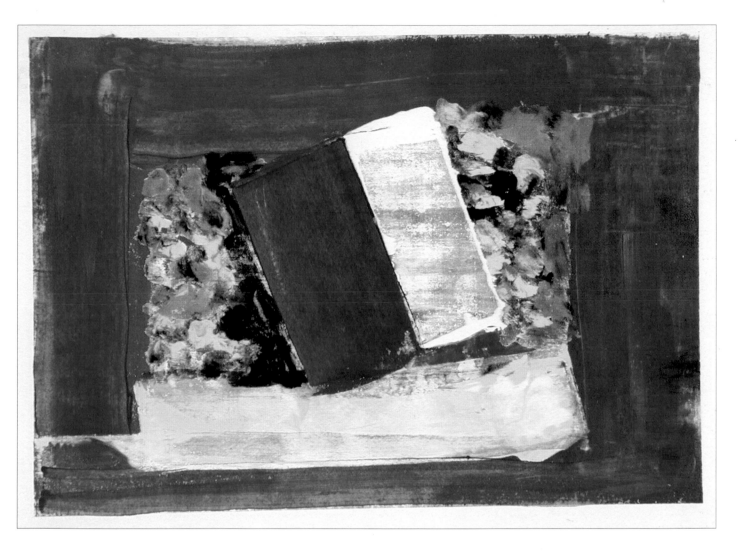

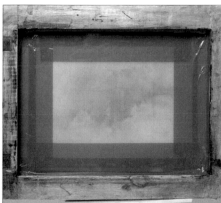

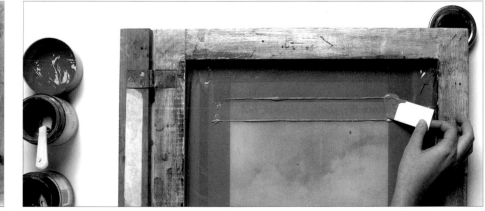

2 Repeat this on all four sides. Polyester screen tape helps to prevent ink bleeding between the mesh and screen frame. Place more strips of tape slightly overlapping the previous ones, working toward the center of the mesh. Continue until your desired image shape is defined.

3 Place the printing paper under the screen. Be sure to position it squarely in relation to your taped image area. Lift the screen from the baseboard slightly at one frame corner, using strips of cardboard or a flat, non-sharp object such as a jelly (jam) jar lid. This is to prevent ink from transferring through to the paper while you are working.

Paint ink onto the mesh with pieces of cardboard, brushes, and plastic palette knives. Here a cardboard square is used to paint the outside borders with a broad sweep of orange. Build up the image working quickly.

Continued on next page

Painting the image

4 The center color work is stippled on with a stiff bristle brush. The final "white" diagonal is added using printing medium applied with cardboard. It is important to work quickly, finishing the image in a matter of minutes to avoid the ink drying into the mesh and blocking it, because this will prevent a print from being taken.

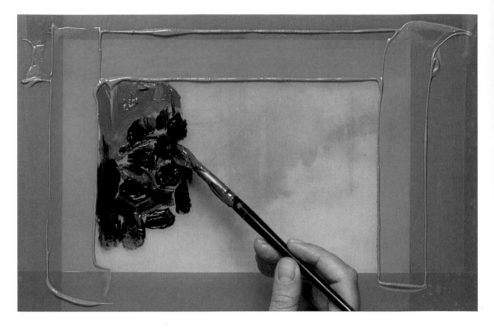

5 It is essential that all areas of the mesh are covered with ink. Any blank areas that are to remain the white of the paper should be blocked in with printing medium, to prevent color simply spreading to unwanted areas when the squeegee is pulled. Remember, it is the first color directly on the mesh surface that will print. It is not possible to layer one color onto another. Once the image is completed, remove the corner spacer.

6 Spoon printing medium onto the screen edge across the whole image width. Squeegee firmly across. Clean the screen immediately (putting newspaper underneath to keep the work surface dry) using a sponge, hot water, and household cleaner.

Tips

■ **If you have the problem of ink drying in the mesh before you print, then add printing medium to your color to dilute it. This will give you longer time in which to work.**

■ **If previously-mixed colors which have been stored in jars have become a little thick, mix in some fresh printing medium and a little water.**

Gallery

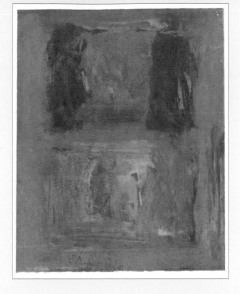

Screen monoprints by
Colin Gale.

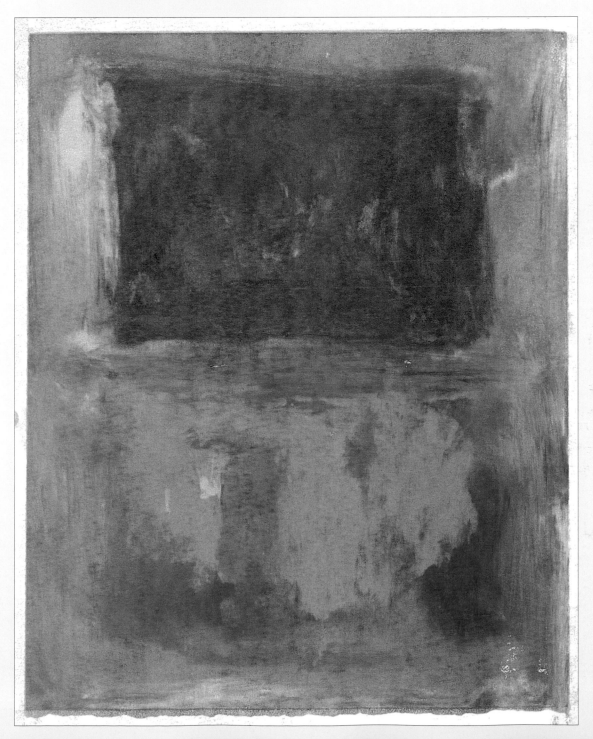

Monoprinting with a Screen
One-off screenprints using crayon

This is another monoprint technique using screenprinting equipment, but instead of using inks (see p.64), the image is drawn directly onto the screen mesh with water-soluble crayons. The one-off crayon drawing is transferred to the paper in stages as it is dissolved through the mesh through the action of the squeegee and water-based printing medium. This method can be used to build up soft impressionistic images, making use of the diversity of hues now available in water-soluble crayons. When purchasing crayons buy good quality ones. They will have a soft creamy consistency giving better coverage - filling the mesh with color. As this method uses crayons and not inks you may take as long as you wish to complete the drawing stage. It is possible with this technique to print over the top of previously printed dried background layers of color, creating prints that have more depth and color density. This medium suits a bold approach as great detail is not achievable.

Opposite: Monoprint using water-soluble crayons.

Tools and materials

You will need:
- Screen and baseboard
- Polyester screen tape
- Water-soluble crayons
- Blunt soft pencil
- Printing paper
- Printing medium
- Acrylic paints
- Jelly (jam) jars
- Plastic palette knives
- Squares of cardboard or matboard
- Jelly (jam) jar lid
- Various paintbrushes
- Spoon
- Squeegee
- Bucket of water
- Sponge
- Old newspapers
- Spray bottle of household cleaner

Water-soluble crayons Spoon, printing medium, acrylic paints and plastic palette knives

Screen, squeegee, polyester screen tape, jelly (jam) jar lid

Cleaning materials

Drawing the image

1 Mask the image area on the screen using polyester screen tape (as explained on pages 60–61). Space the screen from the baseboard using squares of cardboard or a jelly (jam) jar lid at one corner, to prevent the crayon work being transferred to the paper underneath. If it helps, sketch out the basic composition lightly onto the mesh with a blunt soft pencil (this will serve as a guide only and will not affect the final print). Begin building up the composition using the water-soluble crayons. Here sketches drawn in the landscape are used as source material for an abstract design.

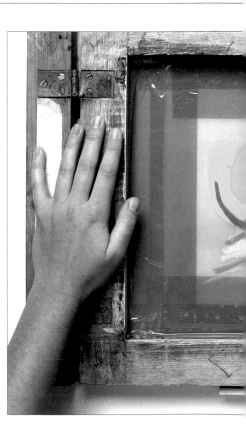

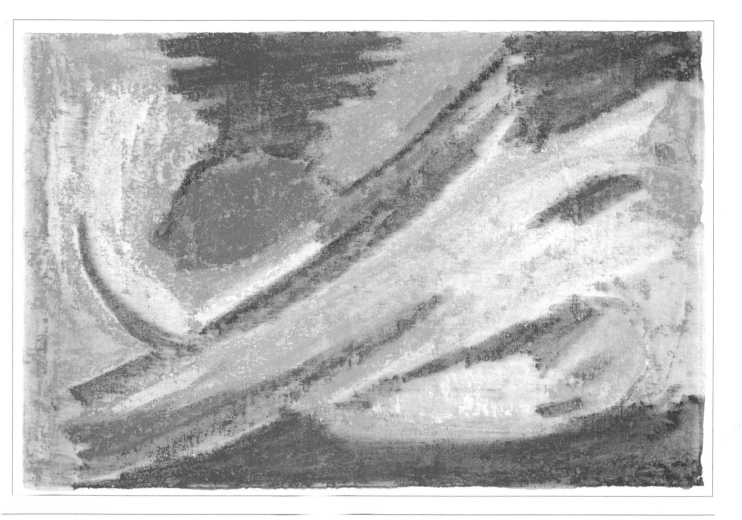

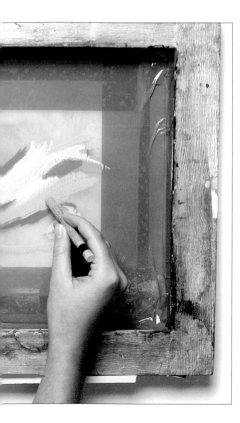

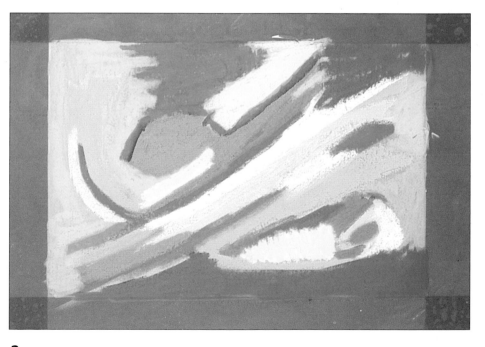

2 Complete the drawing by blocking in the whole image, concentrating on bold color areas and strong shapes such as the trees. It is important to put down a heavy layer of crayon to produce a good deposit onto the paper when printed.

Continued on next page

Printing

3 Remove the cardboard spacer and place a sheet of paper under the mesh making sure it is parallel to your image area. Register using cardboard tabs held with masking tape, two for the corners and one for the leading edge.

4 Spoon printing medium onto the screen edge across the whole image width.

5 Firmly squeegee the printing medium across the screen.

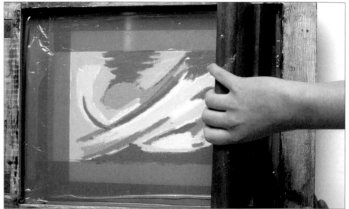

6 Then with the squeegee angled the opposite way, push back the medium to the starting position. Pull the squeegee again toward you. This repeated squeegee action dissolves the crayon in stages, forcing it through the mesh onto the paper.

7 Lift the screen and remove the print. The print is likely to be stuck to the back of the mesh, and you will need to peel it off slowly starting at one corner. The first print will be a faint impression of your image. Place a second sheet of paper in register under the screen. Add fresh printing medium if needed. Again squeegee firmly; flood the medium back and squeegee again. Peel off the second print. You should see a much stronger image.

8 Make a third print on a fresh sheet of paper, and the image will have fully transferred onto the paper. Subsequent prints may be pulled, but as the crayon becomes fully dissolved you will be left with faint ghost images. These will have a quality of their own or may form the starting point for further works. Clean the screen and equipment on newspaper and clean using hot water, a sponge and household cleaner.

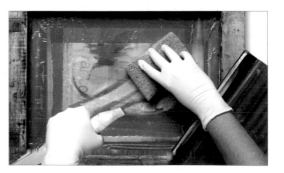

Tip

The amount of pulls needed will vary with each image and mark-making style. Different brands of printing medium and crayons will also affect the number of pulls needed to transfer the crayon. With experience you will be able to control the results more closely.

Gallery

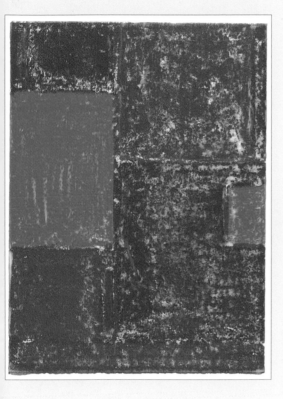

Monoprint with a screen by Megan Fishpool.

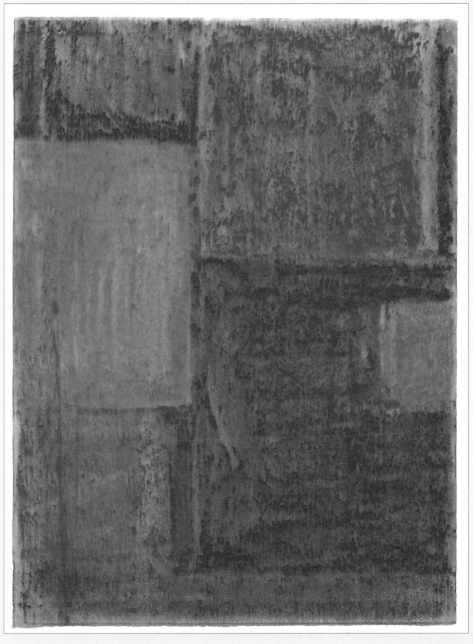

Monoprint with a screen by Megan Fishpool.

Part Two

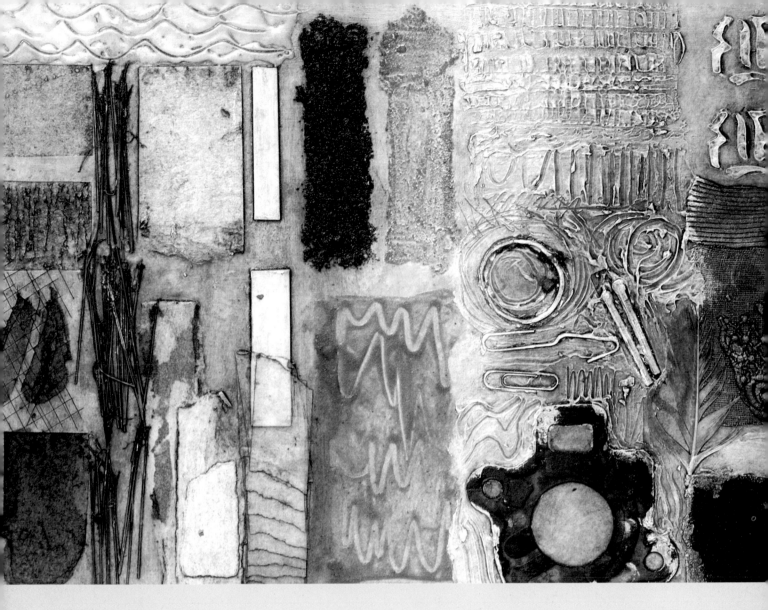

Advanced Techniques

Drypoint on cardboard
Intaglio printing from laminated cardboard

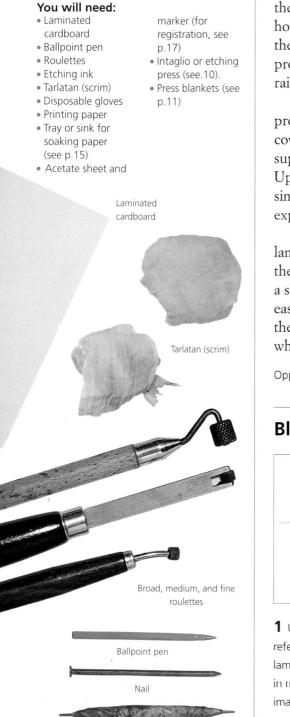

Laminated cardboard

Tarlatan (scrim)

Broad, medium, and fine roulettes

Ballpoint pen

Nail

Spike and handle

Traditionally, drypoint prints are made by working directly onto a copper printing plate with a hard-pointed instrument. The process is *intaglio*—the print is made by rubbing ink into the recessed lines. With drypoint, however, the ink not only collects in the inscribed furrows but also around the raised burrs of metal on both sides of the marks made in the drawing process. This gives drypoint its fuzzy lines, but since these are created by raised metal, the plate deteriorates quickly as impressions are pulled.

Drypoint on cardboard is a means of producing prints similar to those produced on metal plates but at a fraction of the cost. The thin cardboard is covered in a plastic laminate, which can be bought ready-prepared from art suppliers, or you can coat the cardboard yourself with a laminating machine. Up to 20 prints can be made before the cardboard begins to deteriorate, a similar number to that possible with a metal plate. This method gives bold, expressive line and tone, but should not be used if fine detail is wanted.

Another advantage of drypoint on cardboard is that you can draw on the laminated surface with a ballpoint pen. This can be easily wiped away once the cutting in and sample inking takes place. The final marks are made with a sharp metallic tool such as a large carpenter's nail or metal skewer. For ease of use, handles can be added to these by wrapping masking tape around the shaft. Traditional drypoint tools, such as a roulette (a spikey-surfaced wheel), can also be used.

Opposite: Drypoint on cardboard print in black etching ink on off-white textured paper.

Blocking in tone

1 Using a sketch or a photograph as a reference, begin by lightly drawing onto the laminated surface using a ballpoint pen. Keep in mind that the final print will be a reversed image of what appears on the plate. If necessary, transpose the drawing with the aid of a small mirror.

2 With the broad roulette, begin toning the main areas of the composition. Use a smaller roulette for working into the edges of the tonal areas. Work the roulettes in a variety of directions to build up rich textural effects.

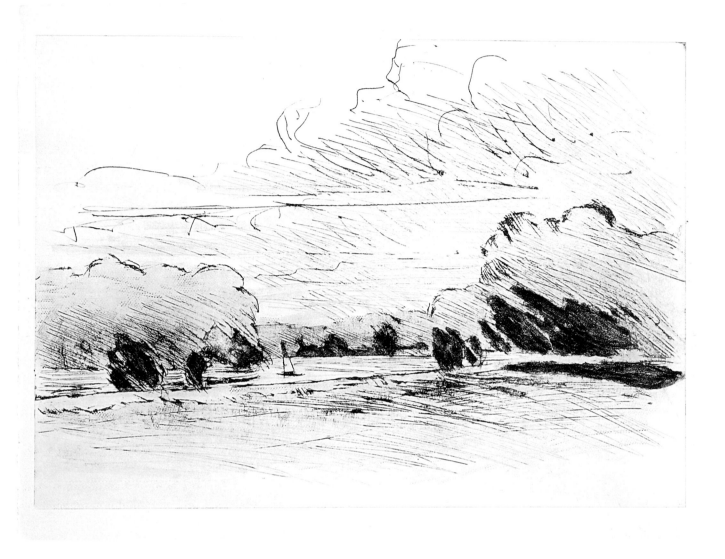

3 When this initial toning is almost complete, give the plate a trial inking to assess the work so far. Use disposable gloves to protect the hands from the oil-based ink. Apply the ink with a pad of tarlatan (scrim). Work the ink into the inscribed marks with a firm, circular motion.

4 Complete the inking and wipe the surface clean with fresh tarlatan (scrim) leaving it clear and the ink in the inscribed "gullies." This gives a reasonably accurate impression of the drawing so far. Each time you ink up, the ink will permanently stain the newly drawn marks, allowing you to see the image as it progresses.

Continued on next page

Adding drawing

5 Begin the linear drawing of the image using the pointed metal implement. Use the tool forcibly to get bold, vigorous marks. Don't worry if this removes small slivers of the laminate; simply brush these away and continue drawing.

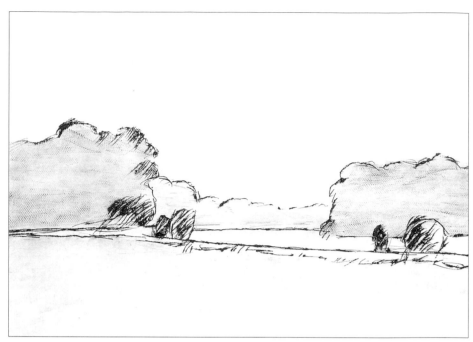

6 Ink up again, as before, in order to assess this latest stage of drawing. Give the cardboard plate an all-over visual check, looking for any white scored lines that the ink has missed and apply more ink where necessary.

7 Using the finest roulette (which is little more than a toothed wheel), add linear tone to the already established tonal areas. Build this additional texture carefully and use cross-hatching to enhance the textural patterning. Add linear tone to the sky.

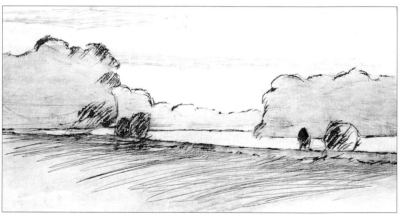

8 Ink up once more to re-assess this stage of the drawing. When wiping away the surplus ink, be certain to clean the surface area completely to get a proper rendition of what will ultimately print.

9 Darken the tone of the nearer riverbank to enhance the sense of pictorial depth. If necessary, you can assess newly drawn areas by inking them up on their own.

11 Ink up again for re-assessment. A rich variety of textural detail is formed by using the range of tools in combination with each other.

10 Work into the darker areas of the drawing with the pointed implement. Again, don't worry if areas of laminate are removed; the image will print rich, deep blacks in these fully exposed areas.

12 Go over the whole image, adding tone and final details such as the yacht on the river.

The printing process

13 Now the plate is ready for printing. Cut the paper so that it is larger than the cardboard, to provide a generous border all around. These sheets should then be soaked in clean water (see p.15) to allow them to absorb the ink from the cardboard plate when put through the etching press. When inking for the actual printing process assiduously rub the ink over the whole plate, pushing the ink well into the graven areas. When wiping down, work across any linear areas; do not wipe along the line because this will remove ink from the recessed marks.

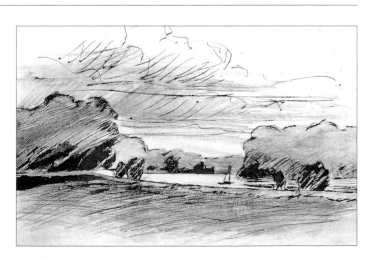

Gallery

Drypoint cardboard print by Maxim Kantor.

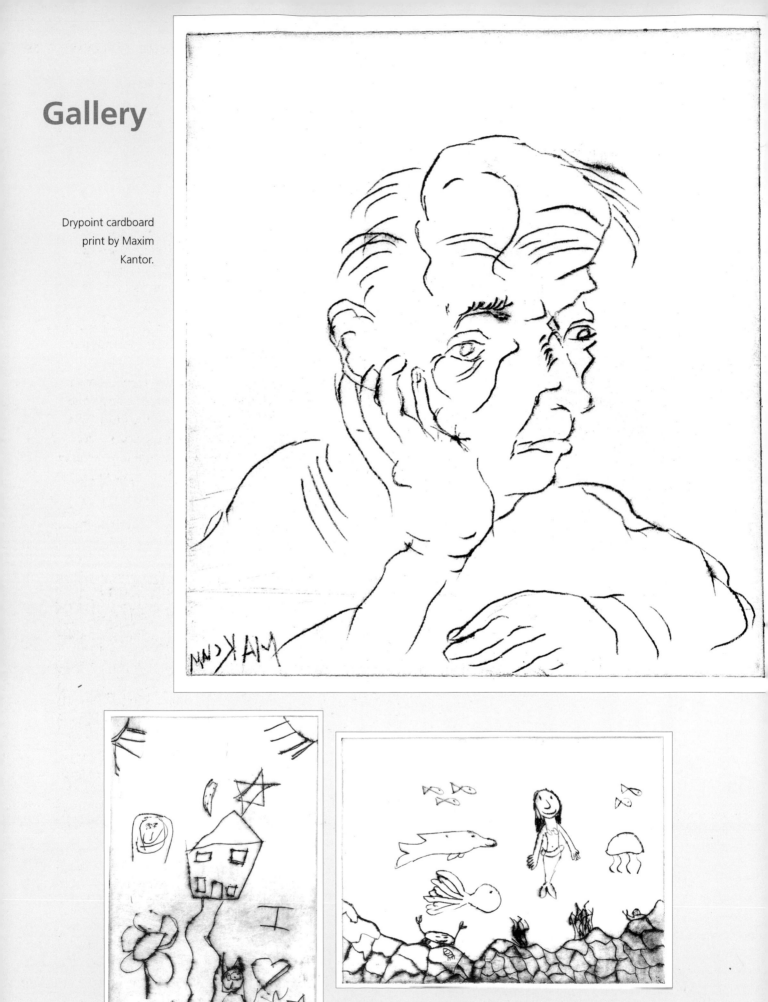

Drypoint cardboard prints by school children aged 8 and 12.

Drypoint on Plastic
Intaglio printing from an acrylic sheet

Tools and materials

You will need:
- Acrylic plastic sheet
- Fine-point permanent marker
- Heavy-duty mat (craft) knife
- Steel rule
- A medium file
- A selection of cutting/marking tools
- Roulette
- Sheet of black paper
- Tarlatan (scrim)
- Black etching ink
- Disposable gloves
- Printing paper
- Tray or sink for soaking paper (see p.15)
- Acetate sheet and marker (for registration, see p.17)
- Intaglio or etching press (see p.10)
- Press blankets (see p.11)

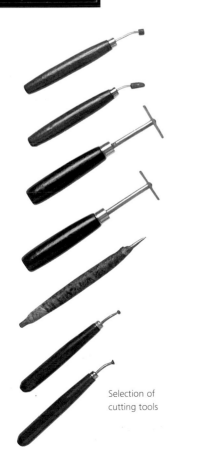
Acrylic plastic sheet and sheet of black paper

Selection of cutting tools

Another inexpensive way of experiencing the direct and beautiful technique of drypoint is to use sheets of plastic as printing plates. By starting off with simple images and concentrating on strong line, it is possible to discover the range of different textures and tones that are possible with the drypoint technique.

An acrylic sheet can be purchased from a hardware store or an art supply store. It is intended primarily as an alternative to glass for the construction of windows in greenhouses and other outbuildings.

The sheet will usually have precise cutting instructions on its protective wrapping, but this is usually carried out with a heavy duty mat (craft) knife. Make sure the knife is fitted with a new blade; do not attempt to cut with a blunt one. Mark the sheet with a permanent marker and use a heavy steel rule to guide the cutting. The sheet must be scored with the knife repeatedly until it is cut at least three-quarters of the way through. Then it is safe to snap off the length on the edge of a table.

Drypoint on plastic printed in black etching ink on off-white textured paper.

Continued on next page

Preparing the plate

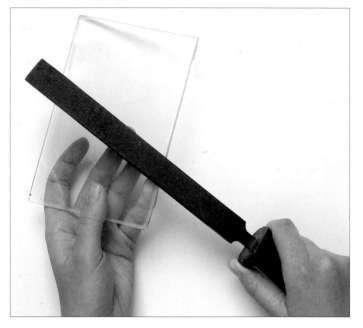

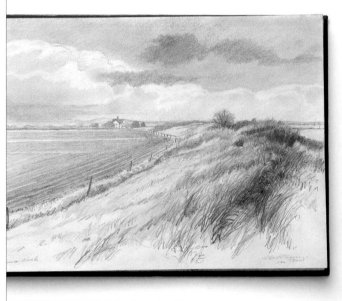

1 Once you have cut the sheet to size, use a medium file to "bevel" all the sides, smoothing away all the sharp edges. It is important to do this well since the plastic is thick and could easily cut the press blankets.

2 One advantage in using clear material is that it can be laid over a sketch and the design traced upon it. Select a sketchbook drawing.

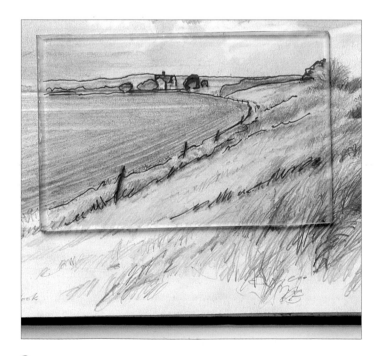

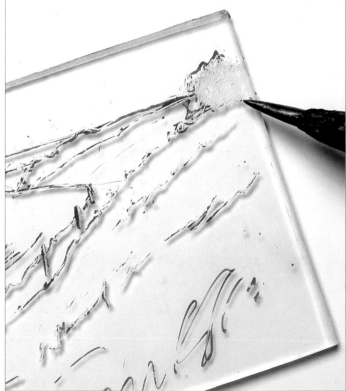

3 Place the plate over the drawing in a position that creates a good composition. Using a fine-point permanent marker, draw in the main lines of the composition.

4 With a drypoint tool, scratch in the bushes and distant trees.

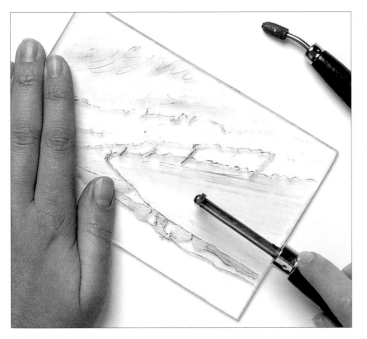

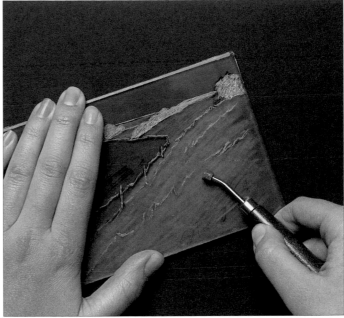

5 Here, an irregular roulette made of carborundum is used to create heavy tones in the foreground and the long grass embankment. This tool has a head that rotates, it is very rough and "plows" up the surface with random marks that will hold a lot of ink. A variety of roulettes are used to create tonal areas in the foreground and the plowed field on the left.

6 At this stage place the plate onto a sheet of black paper in order to assess the composition.

Printing

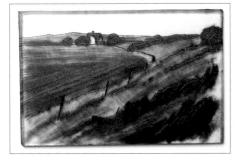

7 Soak the paper and ink up the plate in the standard fashion for an intaglio print (see p.83).

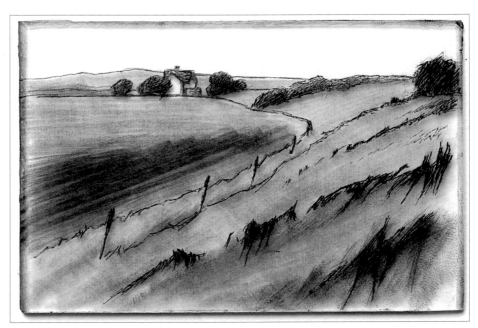

8 Before printing make sure the correct pressure is set on the etching press (see p.10). Plastic is usually thicker than a standard metal plate used in etching. When using a press you are not familiar with, always seek advice about press pressure from the owner before printing.

Continued on next page

Gallery

Drypoint on plastic by Megan Fishpool.

Drypoint on plastic by Megan Fishpool.

Drypoint on Aluminum

Intaglio printing from soft metal

Tools and materials

You will need:
- Aluminum sheet
- Metal guillotine
- Fine-point permanent marker
- A metal file
- A selection of cutting/marking tools
- Selection of roulettes
- Burnisher
- Light oil
- Empty ballpoint pen
- Black etching ink
- Tarlatan (scrim)
- Disposable gloves
- Printing paper
- Tray or sink for soaking paper (see p.15)
- Acetate sheet and marker (for registration, see p.17)
- Intaglio or etching press (see p.10)
- Press blankets (see p.11)

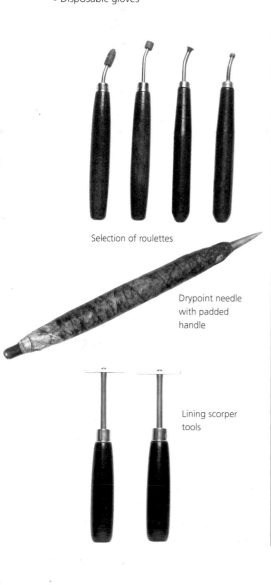

Selection of roulettes

Drypoint needle with padded handle

Lining scorper tools

The third project using the drypoint technique uses an aluminum plate. Aluminum is a very soft metal, which means it is easy to work. But its softness has other advantages too—in drypoint; the ink is not only held by the lines scratched into the metal, but also by the displaced metal, or "burr," which is kicked up when the tool cuts into the surface. It is this burr that gives the drypoint line its unique rich, velvety look—and this is easy to create with aluminum.

Aluminum can be purchased from metal merchants in large sheets, usually 6 ft x 3 ft (2m x 1m), and around ¹⁄₂₄ in (1mm) thick. For a small charge they will guillotine it in to smaller sizes. It is also worth asking for the sheet to be plastic-covered on one side, since this will keep the surface scratch-free until it is needed. Hardware stores may stock smaller pieces of aluminum. A free source of aluminum that can be tracked down with a little work are used lithographic plates from commercial printers. The back of these plates, which can be just ¹⁄₈₀ in (0.3mm) thick, are perfectly serviceable for making drypoints on.

If you find that drypoint is the medium for you, you can progress to working on copper. Copper is considerably harder than aluminum and will yield a much larger edition before the burr begins to wear out.

> **Tip**
>
> Make the first print a good one. It will be the best impression since the burr will be at its strongest. With subsequent prints the burr will begin to wear, holding less ink, and won't have the intensity of the initial print.

Preparing the plate

1 Cut the plate to size using a metal guillotine and bevel all the edges using a file. Plan the image using a permanent marker.

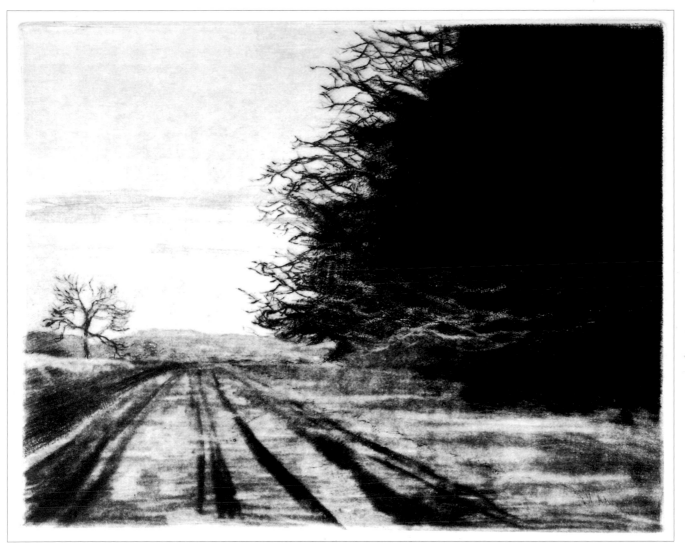

Drypoint on aluminum printed in black etching ink on off-white textured paper.

2 With a drypoint needle, scratch through the drawn lines to create the main composition. To check progress at this stage, a little printing ink may be wiped into the lines to show them more clearly. Make a small "dauber" by tightly rolling a piece of tarlatan (scrim). While wearing gloves, dip the dauber into etching ink and gently work it into the scratched lines. Carefully wipe off any excess ink.

3 Using the irregular roulette, vigorously work in the large trees on the left to create an intense tone.

Continued on next page

4 To check your progress, rub in more ink with a tarlatan pad (scrim).

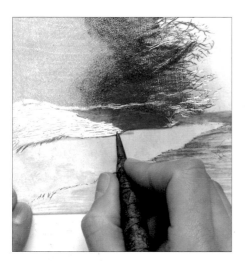

5 Using the main drypoint tool, add the darker areas under the tree to create depth. The more prominent branches on the front of the tree were scratched in.

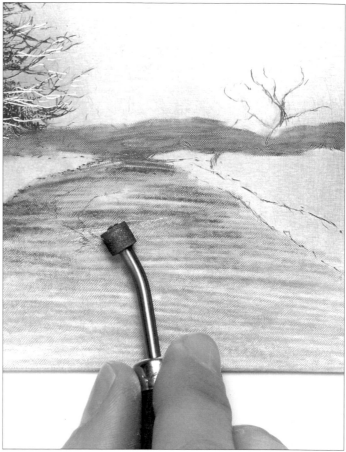

6 Next, use a fine, regular roulette to add the distant trees. With the same tool but using slightly more hand pressure, make marks in the middle ground to the foreground, to give the track perspective.

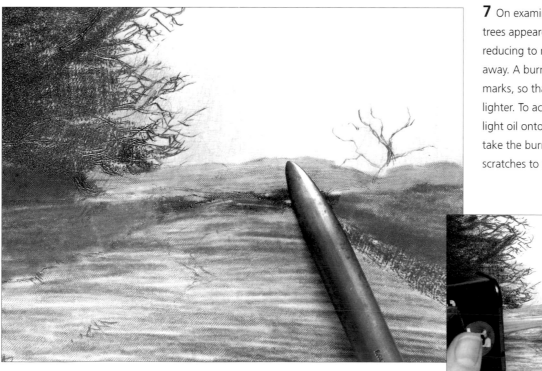

7 On examination of the image, the distant trees appeared too dark. The tone needed reducing to make the trees appear further away. A burnisher was used to rub back the marks, so that they hold less ink and print lighter. To achieve this, squeeze a drop of light oil onto the plate (see inset below). Then take the burnisher tool and gently rub the scratches to reduce them.

8 With a scorper tool create the furrows in the track that recede into the distance. Add a few large puddles to the track using a roulette. Scrape back the areas, removing tones to represent water. The idea is to create a scene showing recently passed heavy rain.

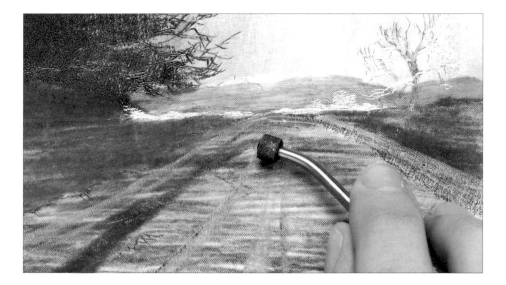

9 Add further detail to the main track and the areas to the left.

10 To finish the piece, an improvised tool was used—an empty ballpoint pen. The tiny ball at the end of the pen is pressed down making a slight indentation. This "tool" is excellent for making soft marks and is used here to make the sky look far away in the distance.

Printing the plate

11 Ink up the finished plate with the dauber, making sure ink is worked gently into all the lines and scratches. A clean tarlatan pad (scrim) is used to wipe back the excess ink. Wipe in gentle circular motions. Print in the normal way onto dampened paper. Always use high quality paper to print on for best results.

Gallery

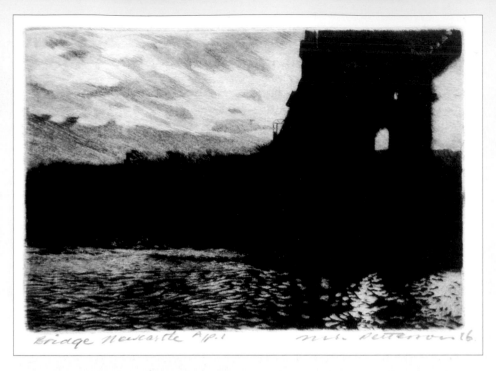

Drypoint on aluminum
by Melvyn Petterson.

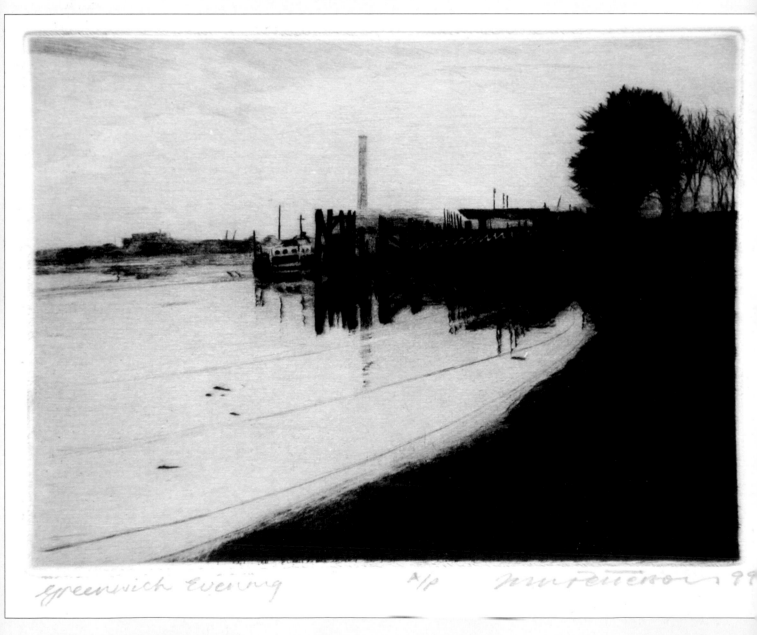

Drypoint on copper by Melvyn Petterson.

Hard Ground Etching
Intaglio prints using zinc and acid

Tools and materials

You will need:

- Sheet of zinc
- Medium metal file
- Whiting powder (chalk)
- Trays
- Running water
- Felt pad or cotton ball
- Fan or hairdryer
- Hot plate
- Hard ground wax or acrylic
- Medium-hard rubber roller
- Palette knife
- Hand vice
- Wax tapers and matches
- Selection of etching tools
- Roulettes
- Steel (wire) wool
- Straw-hat varnish or stop-out varnish
- Soft paintbrush
- Nitric acid (or ferric chloride)
- Safety goggles
- Acid-resistant gloves
- Acid extraction unit
- Feather
- Denatured alcohol (methylated spirit)
- Kerosene (white spirit)
- Cotton rag
- Black etching ink
- Squares of matboard
- Tarlatan (scrim)
- Disposable gloves
- Printing paper
- Tray or sink for soaking paper (see p.15)
- Acetate sheet and marker (for registration, see p.17)
- Intaglio or etching press (see.10)
- Tissue paper
- Press blankets (see p.11)

Steel (wire) wool

Felt pad

Selection of etching tools and roulettes

Whiting powder (chalk)

Etching, like drypoint, is an intaglio printmaking technique. Instead of using tools to directly work the plate, however, the lines that hold the ink are added chemically using a "mordant," typically an acid. To create the design, the metal plate is covered in a substance that is resistant to acid, known as a "ground." Using pointed tools, the design is drawn into the ground, to reveal the metal below. When placed in an acid bath, the acid "bites" where the metal has been revealed, creating furrows which will hold the ink during the printing process.

The depth of bite is controlled by the length of time left in the acid. A short time in the acid will result in a shallow bite that will print a light tone. A longer time in the acid will etch a deeper line that will hold more ink and print darker. Zinc is the ideal metal to start with. It is relatively inexpensive, and it is relatively quick to bite in the acid. Buy sheets that have a plastic protective coating on one side to make sure that you begin with a scratch-free, polished surface.

Two ways of laying a hard ground are demonstrated in this project. The traditional method involves rolling a coating of hot wax over the plate. An alternative, which does not require a hot plate, is to use an acrylic ground which is poured on the metal.

Continued on next page

Preparing the plate

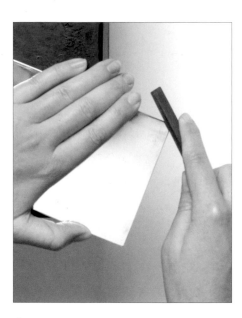

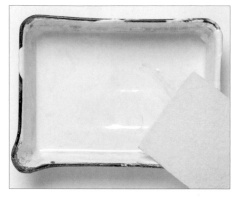

2 Before laying a wax ground, the surface of the plate must be thoroughly degreased. In a small tray, mix whiting powder (chalk) with water until you have a creamy consistency.

3 With a felt pad or cotton ball, rub the white paste over the surface of the plate. Pay particular attention to the outside edges of the plate.

4 Rinse the plate well in cold running water. Make sure all the chalk is removed. You will see if there are any greasy patches remaining by the way the water runs off the plate—the water should run down the surface evenly. At this stage handle the plate by supporting it underneath to avoid transferring grease from your fingers onto the surface. Prop the plate up against something firm and let it dry in front of a fan (or use a hairdryer).

1 Smooth the plate's sharp edges using a medium-cut file. File all four sides to create beveled edges, and round off the corners.

Applying the ground

5 Place the cleaned plate on a hot plate with the degreased surface facing up. The temperature should be just hot enough to melt some wax from the ball of hard ground when it is rubbed onto the surface.

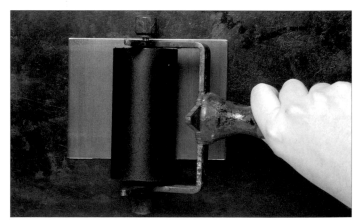

6 Using a medium hard rubber brayer (roller), roll the ground evenly over the plate surface (above), then use a putty (push) knife to carefully remove the plate from the hot surface.

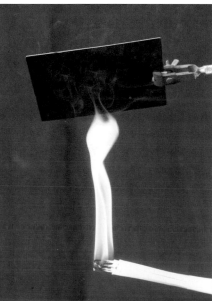

7 Remove the plate to a cool surface and leave it to cool completely. The plate may be worked on at this stage, but it is often the practice to smoke the ground to darken it. This makes the drawing easier to see since the bright metal shows in strong contrast against the dark ground. To smoke the plate, clamp one edge with a hand vice. Light approximately six wax tapers. Hold the plate with the ground facing down and slowly pass the tip of the flame over the wax surface (left). The hard ground will turn to a shiny black. Lay the plate face up to cool down and unclamp the hand vice.

Applying the ground (acrylic)

An alternative to using wax is to use an acrylic hard ground. Hold the degreased plate vertically over a plastic tray. Pour a line of the acrylic liquid over the top of the plate and allow it to run down the plate's surface. Tilting the plate when necessary, make sure the surface is covered in ground. Lay the plate onto newspaper and allow to dry. Excess ground from the tray is poured back into the container, which is then rinsed in hot water to clean it. There is no need to "smoke" acrylic ground; it contains a dye, so it easy to see where marks have been made.

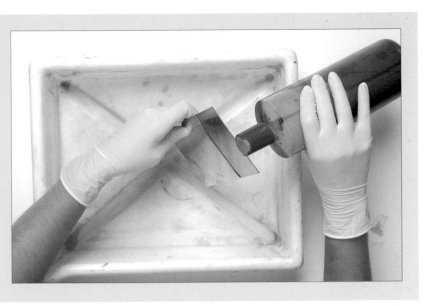

Drawing the plate

8 Make marks by drawing through the wax (or acrylic) ground—using a selection of etching tools, roulettes, and steel (wire) wool.

9 Unwanted areas and mistakes are stopped out using stop-out varnish applied with a soft brush.

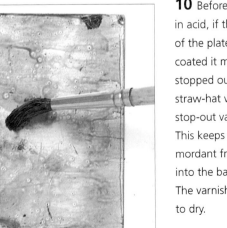

10 Before etching in acid, if the back of the plate is not coated it must be stopped out using straw-hat varnish or stop-out varnish. This keeps the mordant from biting into the bare metal. The varnish is left to dry.

Continued next page

The etching process

Tip

To etch without a ventilation system use ferric chloride acid because it does not give off noxious fumes. It is supplied as a liquid, diluted to a strength known as "45° Baume." To bite zinc, dilute this further, mixing one part ferric chloride liquid to seven parts water. For copper mix one part ferric to two parts water.

11 Prepare a bath of nitric acid (one part nitric acid, ten parts water) by adding the acid to the water – never the reverse. Nitrc acid must be used under a ventilation system that takes away the poisonous fumes. Always use safety goggles and acid-resistant gloves. With a feather, brush away bubbles of gas that form on the surface where the metal is biting. (If a proper extraction system is unavailable—see *Tip* box left.)

Printing the etching

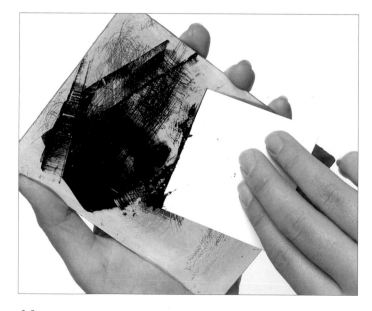

14 Proof the plate in black ink. Place etching ink from the tin or tube directly onto the inking surface. Use a square of matt board to spread ink onto the entire plate surface, making sure the ink is pushed down into the bitten lines.

15 With a pad of tarlatan (scrim), wipe the plate in light circular motions. The excess ink is gently removed from the surface. Ink remains in the bitten lines and furrows.

12 Different parts of the image can be bitten to different levels, depending on how long they are exposed to the acid. To bite the plate to create three different levels of tone, first immerse it in the acid for two minutes. Take out and rinse under running water and dry. This is the "first bite." Then areas that seem sufficiently bitten by the acid are covered with stop-out varnish and allowed to dry.

13 Place the plate in acid again for four minutes. Stop out more areas. Return the plate to the acid for six more minutes, to give a total biting time of 12 minutes. Clean off the plate using cotton rag—use kerosene (white spirit) to remove the ground and varnish from the front, and denatured alcohol (methylated spirit) to remove the straw-hat varnish from the back. Use liquid metal polish to shine up the plate surface before printing.

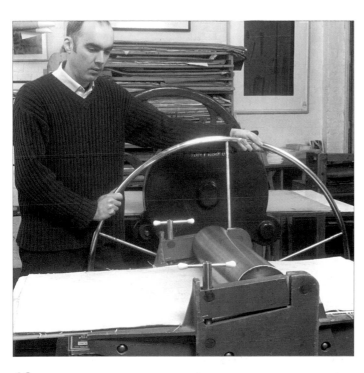

16 To print, place the plate face up on the press bed on a sheet of tissue paper to keep the bed clean. Place a sheet of damp paper over the plate. Smooth the press blankets over the paper and roll the press.

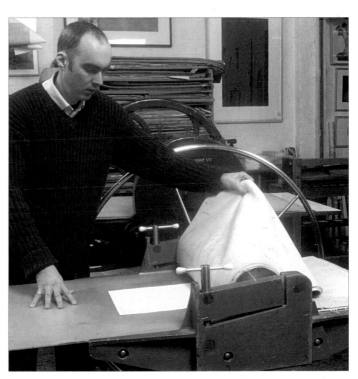

17 The blankets are pulled back and the print is carefully removed. The final print is shown on p.85.

Gallery

Etching by Colin Gale printed
from two steel plates.

Hard ground and aquatint on
copper by Megan Fishpool.

Hard ground
etching on copper
by Alan Wilkie.

Hard ground etching on copper by Joseph Winkelman.

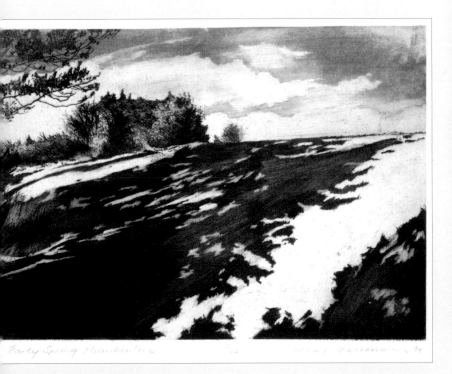

Hard ground etching and aquatint on zinc printed in a black/brown ink mixture by Melvyn Petterson.

Etching printed from a single steel plate inked in three colors by Megan Fishpool.

Soft Ground Etching
Intaglio prints using zinc and acid

Tools and materials

You will need:
- Sheet of zinc
- Metal file
- Hot plate
- Soft ground ball
- Medium-hard rubber brayer (roller)
- Palette knife
- Corrugated cardboard
- Bubble wrap
- Thin smooth paper, or newsprint
- HB pencil
- Old stiff toothbrush
- Stop-out varnish
- Soft paintbrush
- Trays
- Nitric acid (or ferric chloride)
- Safety goggles
- Acid-resistant gloves
- Acid ventilation unit
- Feather
- Running water
- Kerosene (white spirit)
- Cotton rag
- Black etching ink
- Squares of matt board
- Tarlatan (scrim)
- Disposable gloves
- Printing paper
- Tray or sink for soaking paper (see p.15)
- Acetate sheet and marker (for registration, see p.17)
- Intaglio or etching press (see p.10)
- Tissue paper
- Press blankets (see p.11)

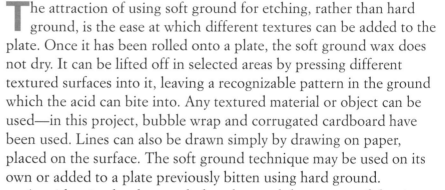

Newsprint and HB pencil

Zinc plate

Stop-out varnish and brush

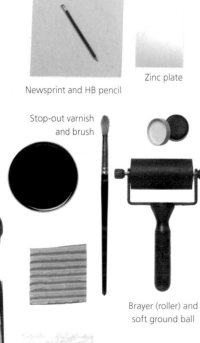

Brayer (roller) and soft ground ball

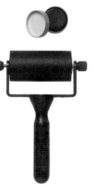

Toothbrush, corrugated cardboard, and bubble wrap

The attraction of using soft ground for etching, rather than hard ground, is the ease at which different textures can be added to the plate. Once it has been rolled onto a plate, the soft ground wax does not dry. It can be lifted off in selected areas by pressing different textured surfaces into it, leaving a recognizable pattern in the ground which the acid can bite into. Any textured material or object can be used—in this project, bubble wrap and corrugated cardboard have been used. Lines can also be drawn simply by drawing on paper, placed on the surface. The soft ground technique may be used on its own or added to a plate previously bitten using hard ground.

As with using hard ground, the edges and the corners of the zinc should be filed before etching (see *Preparing the plate*, p.88). However, since soft ground is inherently greasy, it is not necessary to degrease the plate.

Preparing the plate

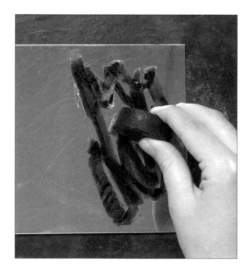

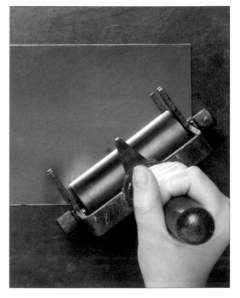

1 Place the zinc plate onto the hot plate set on warm to medium heat. Rub the soft ground ball over the plate surface. Some of the ground should melt on contact with the plate, leaving a thin film of wax.

2 Using a medium hard rubber brayer (roller) roll the soft ground evenly over the plate surface. Carefully remove the plate from the heat using a putty (push) knife, allow to cool. It is important to handle the plate by the edges, to avoid fingerprints in the ground.

Soft ground etching on zinc, using textured materials and pencil offset technique.

Using textures

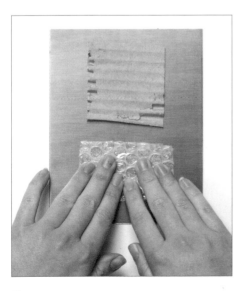

3 Take the corrugated cardboard and press down firmly onto soft ground. Repeat using a piece of bubble wrap. Enough pressure must be applied to lift off the soft ground when the cardboard and bubble wrap are removed.

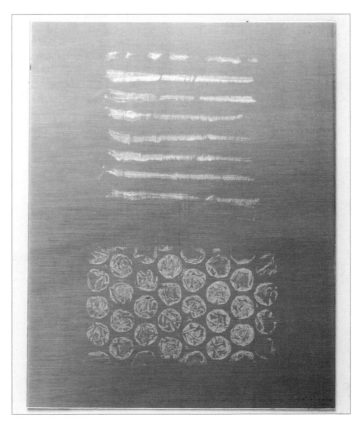

4 The two different materials have lifted parts of the soft ground, leaving patterned footprints. Bare metal is now revealed where the soft wax has been pulled off; it is these areas of the plate that the acid will bite into.

Continued on next page

Using a pencil

5 Lay a sheet of newsprint or thin smooth paper over the plate. With a pencil, draw firmly, adding lines around the previously-made marks.

6 By lifting the paper it is possible to see how the plate is developing. Note how the soft ground has been transferred to the back of the newsprint wherever there was pressure from the pencil.

Printing the soft ground plate

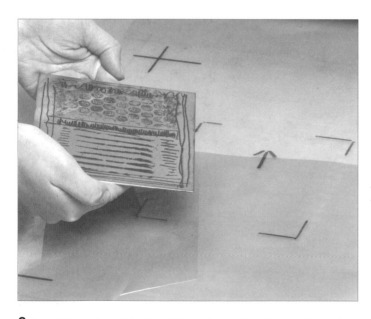

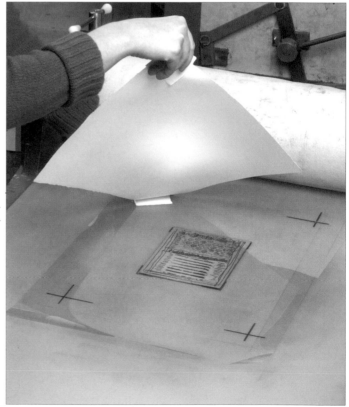

9 A useful way to register the plate and paper together and to make sure the plate is printed squarely on the paper is to mark out a clear acetate sheet with a permanent marker. Crosses drawn at the corners indicate where the paper should be laid, while the rectangle shows the position for the plate.

10 The paper is placed over the plate on the press bed prior to printing. Note that tabs, made from folded paper squares, are used to hold the paper in order to keep it free of inky fingerprints.

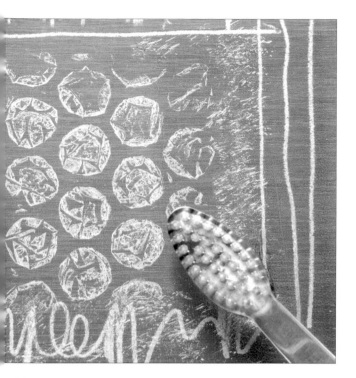

7 Use an old stiff toothbrush to add stipple marks.

Etching the plate

8 Before etching, apply stop-out varnish to the back of the plate (see p.87). When the varnish has dried, the plate is immersed in nitric acid—using the same dilution and the same stringent safety

precautions as with hard ground (see *The etching process*, p.88. Again ferric chloride can be used instead of nitric acid). Wearing heavy duty gloves, remove the plate from the acid after 15 minutes and rinse thoroughly with water. The soft ground and varnish are cleaned off with kerosene (white spirit) and a rag. The plate is inked up and wiped as usual (see *Printing the etching*, p.88).

11 Once the plate has been run through the press, the blankets are pulled back and the print is peeled back from one corner to check the ink has transferred properly to the paper. Study the print quality and and adjust the pressure if necessary.

Gallery

Soft ground etching
by Sheila Yorke.

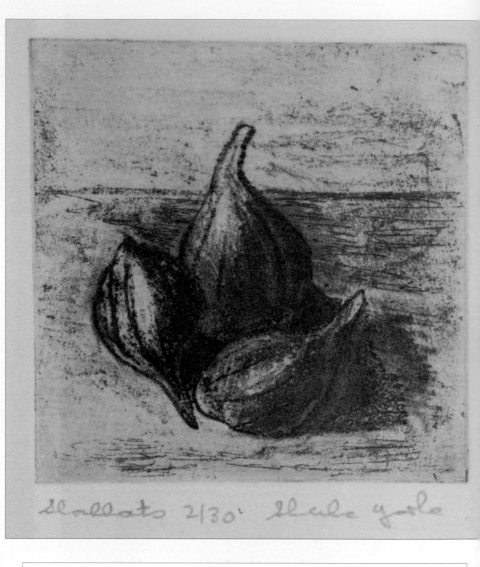

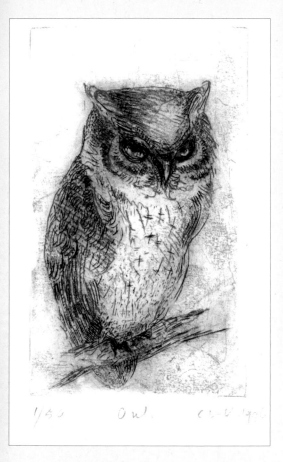

Two-plate two-color etching using hard and
soft ground by Caroline King.

Soft ground and aquatint on
copper by Susan Einzig.

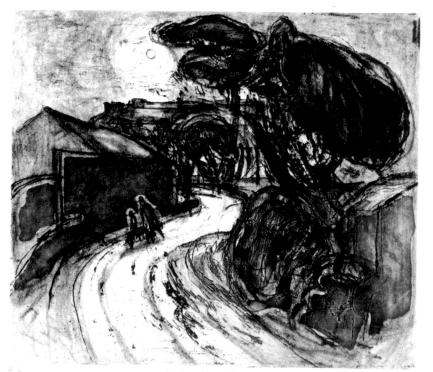

Aquatints
Etching using powdered rosin (resin)

Continued on next page

Aquatint is another intaglio process. Unlike the hard- and soft-ground techniques, however, the ground used with aquatints does not create a solid acid-resistant coating. Instead, it provides a speckled covering that allows the printmaker to add different tonal shades to the etching plate.

The aquatint process was developed as a way to produce watercolor-like washes on a plate, and is usually used in combination with other etching techniques. A plate is covered with a layer of rosin (resin) dust, shaken on by hand or using a special rosin (resin) dust box; a dust mask must be worn. The plate is then heated so that the rosin ground fuses to the surface. When placed into acid, the acid bites around the rosin (resin) granules, forming a random tooth bite. Parts of the plate that do not require this shading can be held back using varnish. The effect can be controlled by how fine the layer of rosin (resin) dust is, and by the length of time in the acid bath.

In this project, we demonstrate how to make a simple test strip that shows the effect of different biting times. As with the previous etching projects, we have chosen to use zinc and nitric acid.

Tools and materials

You will need:
- Sheet of zinc
- Medium metal file
- Whiting powder (chalk)
- Trays
- Running water
- Felt pad or cotton balls
- Fan or hairdryer
- Heating grill
- Dust mask
- Rosin (resin) shaker or dust box
- Gas camp stove
- Stop-out varnish
- Soft paintbrush
- Nitric acid (or ferric chloride)
- Safety goggles
- Acid-resistant gloves
- Acid extraction unit
- Feather
- Denatured alcohol (methylated spirit)
- Kerosene (white spirit)
- Cotton rag
- Black etching ink
- Squares of matboard
- Tarlatan (scrim)
- Disposable gloves
- Printing paper
- Tray or sink for soaking paper (see p.15)
- Acetate sheet and marker (for registration, see p.17)
- Intaglio or etching press (see p.10)
- Tissue paper
- Press blankets (see p.11)

Dust mask

Homemade rosin (resin) shaker

Gas camping stove

Zinc plate

Metal file

Rosin (resin) shaker

To make a hand shaker find an empty can or jelly (jam) jar. Fill it half-full with powdered rosin (resin). Cover the top with several layers of fine tarlatan (scrim) and hold in position with a rubber band or tape. A hand shaken rosin (resin) will give a coarse grain, a proper "dust box" will give a fine grain. Always wear a mask when handling rosin (resin) dust.

Aquatint test strip on zinc showing three biting times.

8 MIN 4 MIN 1 MIN

Continued on next page

Preparing the plate

1 File and degrease the zinc plate (see *Preparing the plate*, p.86). Place the plate onto the heating grill. Wearing a dust mask, hold the rosin (resin) shaker over the plate and tap it with your other hand to shake a fine layer of dust over the entire surface.

2 If you have access to an aquatint dust box, you need to turn the handle a dozen times or so to whip up a cloud of rosin (resin) dust inside. Place the zinc plate onto a larger plate, open the door and slide the plate in. Let the dust settle for between 3 and 4 minutes. Remove the two plates and carefully slide the etching plate onto the heating grill.

3 Using the gas camp stove, heat the plate from underneath. Start heating at one edge. As the rosin (resin) melts it turns transparent. When this happens move the heat across. Let the plate cool; it will be extremely hot! Prepare the acid bath.

> **Tip**
>
> If you want white areas in the image, stop these out first with varnish to prevent the acid biting this part of the plate surface.

Etching the plate

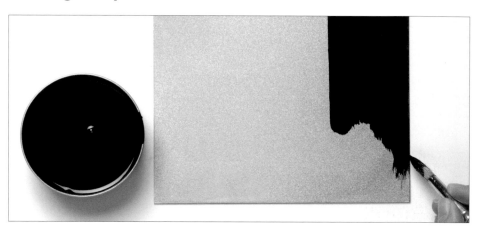

4 If the back of the plate is uncoated, paint it out with varnish and allow to dry. The acid is prepared, and the same safety precautions are observed as in previous etching projects (see *The etching process*, p.88; again ferric chloride could be used instead of nitric acid). The plate is immersed in acid for the first bite for one minute— then removed, rinsed, and dried. To fix the one-minute bite, a strip of stop-out varnish is painted on and allowed to dry.

5 The plate is returned to the nitric acid for a second bite. It is left in the bath for three minutes. This gives a total time in the acid so far of four minutes.

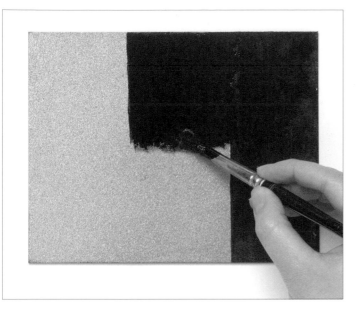

6 The plate is rinsed and dried. A second strip is painted with the varnish. The plate is immersed in the acid bath for another four minutes—giving a total bite time of eight minutes.

7 Now clean the plate. Use kerosene (white spirit) to remove the varnish from the front and back of the plate. Use denatured alcohol (methylated spirit) to remove the rosin (resin).

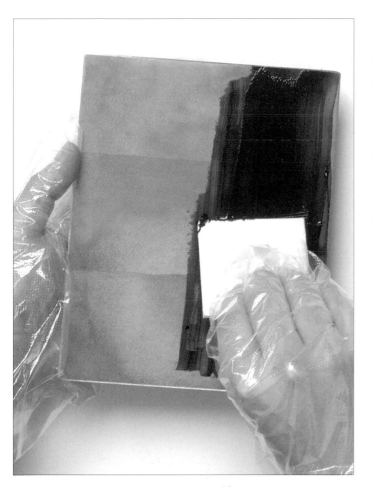

8 The bitten plate is then inked with black etching ink. Wipe the plate with the tarlatan pad (scrim) using gentle circular motions. Print the plate (see *Printing the etching*, p.88).

9 After it has been printed in the etching press, the test strip provides a guide to biting times and the different tonal effects that they achieve. Write the times underneath each strip and hang on the wall above the acid area.

Gallery

Hard ground and aquatint from two copper plates in three colors by Ruth O'Donnell.

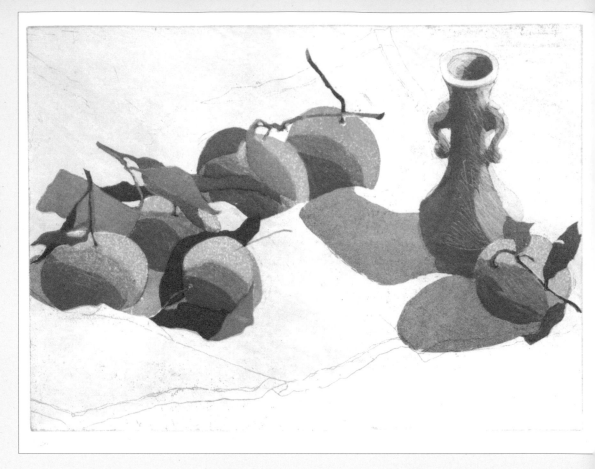

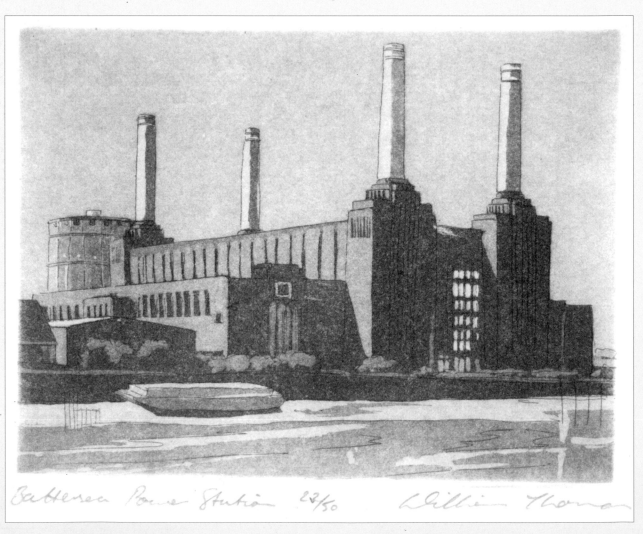

Hard ground and aquatint on zinc printed using sepia ink by William Thomas.

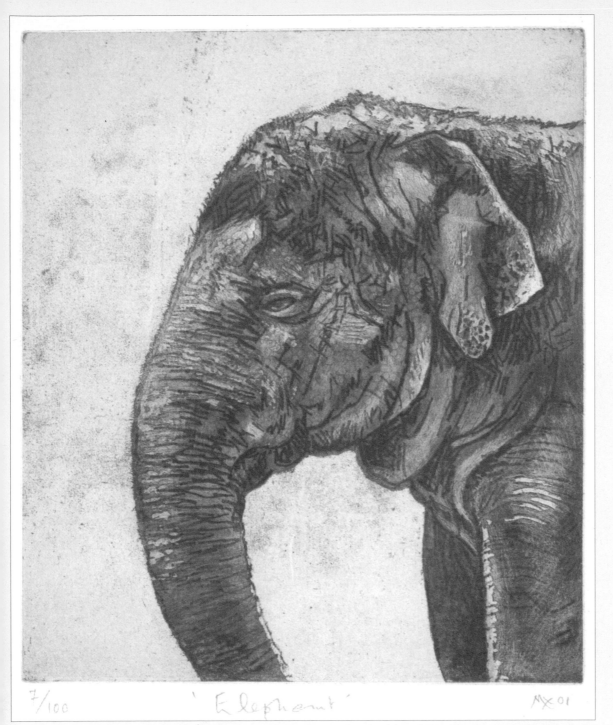

7/100 'Elephant' MX 01

Soft ground and
aquatint on zinc
by Isabel Huchison.

Hard ground and aquatint
on copper by Ruth Uglow.

Collagraphs
Printing from a collage

A collagraph is a print made from a "plate" that is a collage of different textures and materials. It is an intaglio process, in which the ink is held by the contours and edges of the collaged materials. The block consists of a base to which textiles, textured paper, organic material, and other objects are stuck using PVA wood glue. This is one of the cheapest printmaking techniques—all of the objects used in this project were found in the studio.

The only restrictions are height—the objects should not be more than approximately ⅛ in (3mm) thick. This is because the paper will not be capable of being molded into all areas of the block by the roller press if the height differences between the collaged pieces are too varied.

A wide range of less-obvious materials can be used to create the block. Contours can be created using two-part epoxy resin, which will hold the ink in interesting ways. Carborundum powder can be mixed with glue to create gritty textures. Patterns and shapes can be drawn into plaster and automotive body filler. Stepped layers can be made by sticking down and overlapping adhesives tapes.

Tools and materials

You will need:
- Piece of cardboard
- PVA wood glue
- Paintbrushes
- X-acto knife (scalpel)
- Squares of matboard
- Carborundum powder
- Sand
- Selection of objects and materials
- Two-part epoxy glue
- Damp cloth
- Quick-drying household varnish
- Oil-based etching inks
- Toothbrushes
- Tarlàtan (scrim)
- Disposable gloves
- Printing paper
- Tray or sink for soaking paper (see p.15)
- Acetate sheet and marker (for registration, see p.17)
- Etching or relief press (see p.10).
- Tissue paper
- Foam rubber mat (see p.11)

Selection of materials and objects to make collage

Carborundum powder (coarse and fine)

Sand

Masking tape

Two-part epoxy glue

X-acto knife (scalpel)

PVA glue and brush

Tip

Recycle used etching plates as collagraph base plates. Metal plates provide a very stable base and by gluing layers down old marks will be covered. You could also use etched marks, allowing them to show through glued on layers as part of your final image.

Making the base support plate

1 The base support plate should be consistently flat and stable, ½₄–½₂ in (1–2mm) thick is ideal. Matboard and metal plates also make ideal base supports. In this example we have used a square matboard as a base plate. First, the matboard is cut to the required dimensions.

Both sides of the board are then sealed with a coat of PVA glue using a brush. This makes the board more stable to further gluing. Leave to dry.

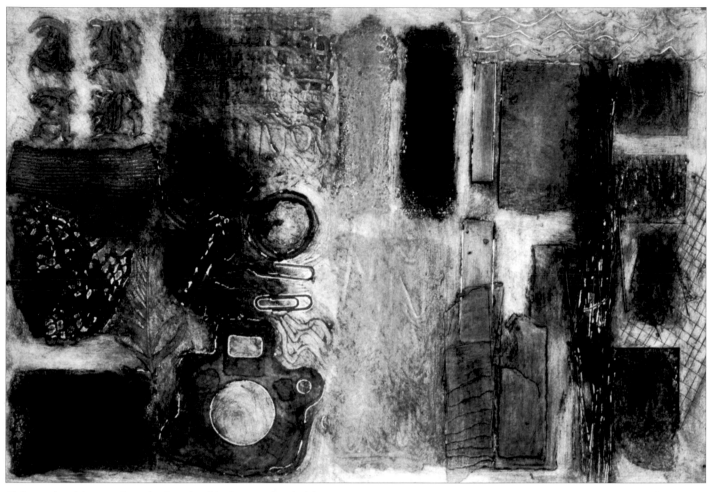

Collograph print on matboard using glued textures and material.

Creating texture

2 The smooth cardboard surface layer can be removed by slicing slightly into it using an X-acto knife (scalpel). Cut the required shape and peel back the surface. The textured surface that you have exposed will hold ink. Varying the cut depth will affect the way in which ink is held. Marks can also be scored into the board using the knife point.

3 Cardboard strips cut and torn into shapes are glued (with PVA) to the base plate.

4 Mix carborundum or sand with PVA glue to form a paste which is painted onto the base plate. Painted on in varying densities, these materials can be used to form tonal variations within the print.

Continued on next page

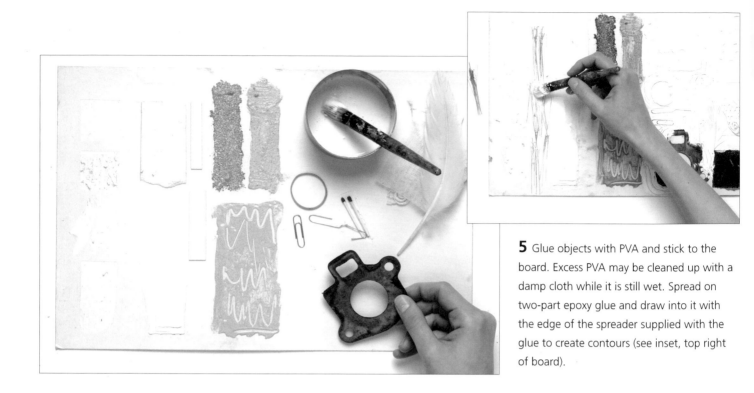

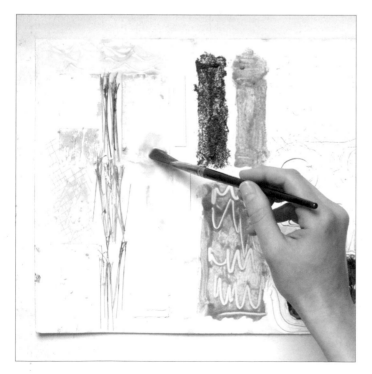

5 Glue objects with PVA and stick to the board. Excess PVA may be cleaned up with a damp cloth while it is still wet. Spread on two-part epoxy glue and draw into it with the edge of the spreader supplied with the glue to create contours (see inset, top right of board).

Sealing your plate

Inking and printing

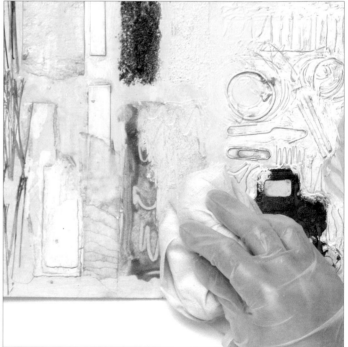

6 Before printing with dampened paper, your plate must be sealed to prevent the possibility of water activating the PVA glue and lifting away parts of your design. To seal the plate, we used a quick drying household varnish. Shellac can also be used although it takes several hours to dry.

7 A pad of tarlatan (scrim), and a roll of tarlatan (a dauber), are used to apply yellow color. Due to the highly-textured nature of the surface, ink needs to be applied more vigorously than with other intaglio processes, working it into and around the textures.

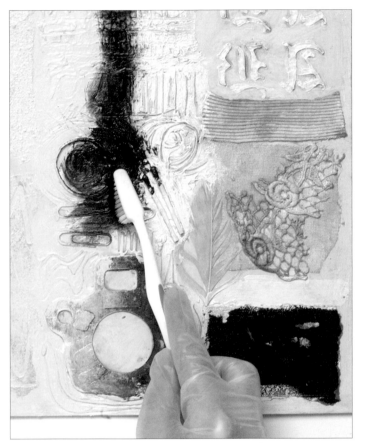

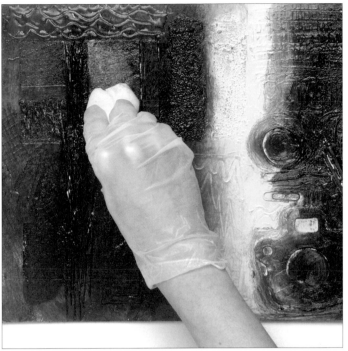

9 Once inking is completed, the excess ink is wiped from the plate surface using a flat pad of tarlatan (scrim).

8 Several colors can be applied to the plate at the same time; the colors will blend, but this adds to the exciting variations possible within each printing. Here dark blue is added to hard-to-reach areas with a toothbrush.

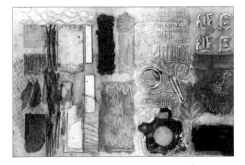

10 The final plate for the collagraph.

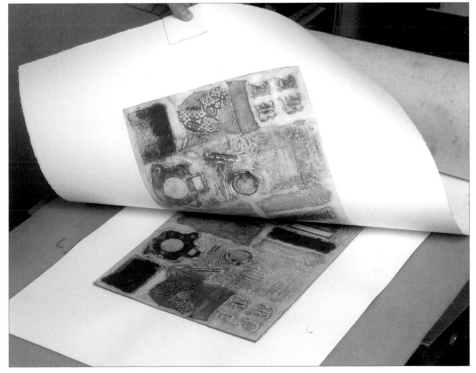

Tip

Try printing your plate uninked on thick textured paper. This is known as blind printing or embossing (see p.44).

11 The inked block is placed face up on the etching bed, a presoaked sheet of paper placed on top and the press is rolled. Your finished block may well be thicker than a standard etching plate, so adjust the press pressure accordingly. Collagraphs can be successfully printed on either an etching press or a relief press.

Gallery

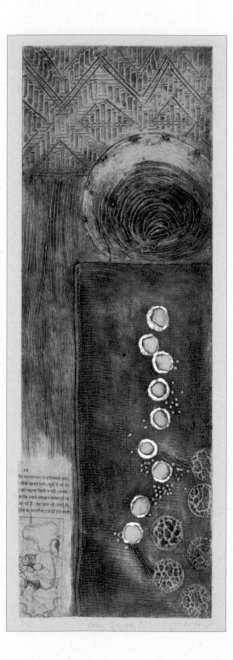

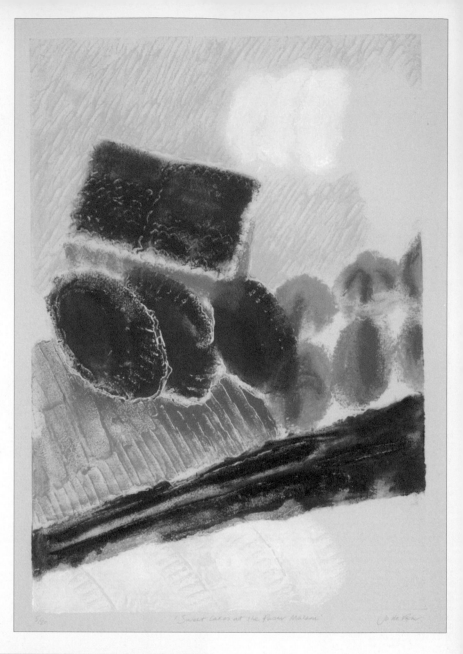

Collagraphs by Jo de Pear.

Collagraph by Emma Grover.

Monoprinting on Plastic
One-off prints with paint and polyester

Tools and materials

You will need:
- Polyester drafting sheet
- Permanent marker
- Small rubber brayers (rollers)
- Oil-based printing inks
- Suitable surface for rolling out ink
- Bristle paintbrushes
- Kerosene (white spirit)
- Cotton rag
- Printing paper
- Tray or sink for soaking paper (see p.15)
- Acetate sheet and marker (for registration, see p.17)
- Etching press (see p.10)
- Tissue paper
- Press blankets (see p.11)

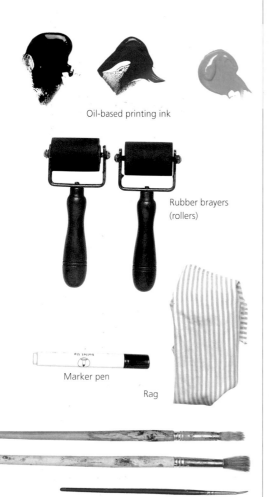

Oil-based printing ink

Rubber brayers (rollers)

Marker pen

Rag

Paintbrushes

Monoprinting is a way of producing spontaneous, one-off images using drawing and painting techniques. The usual question one is asked about monoprints is, why doesn't the artist paint or draw directly onto the paper? The answer is that the way that the inks are transferred during printing creates unique effects which are very different from traditional painting. Monoprints have the ability to produce a whole range of marks—from translucent watercolor tones to dense vibrant swathes of color.

A variety of different materials can be used for the plate, but for this project we have used sheets of grained polyester, sold as drafting film for technical drawing. It is transparent, which is useful for designing the image, and has a random grain on one side (similar to a lithographic plate or stone) which holds the ink. It is possible to hand-print the plates, but much better results occur if an etching press is used.

Any oil-based ink may be used for this project. If you want to avoid using oil-based products, it is possible to use water-based relief printing inks. An alternative method using water-soluble crayons is described on p.110.

Monoprint is a direct printing method; the printed image will be reversed. By using a transparent plate the image can be mapped out on the reverse side of the plate using a permanent marker. The plate is then turned over before painting so that the rough design is automatically reversed.

Opposite: Painted monoprint using textured polyester drafting sheet.

Preparing the plate

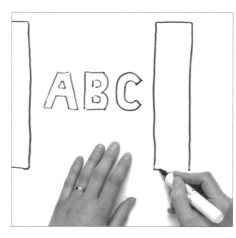

1 Sketch out the main image areas onto the back of the polyester plate (the smooth side) with a permanent marker.

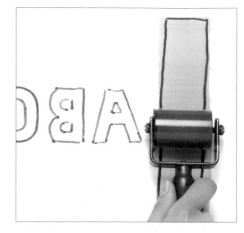

2 Turn the plate over and the design automatically appears reversed. Lay down the first color inks using a roller.

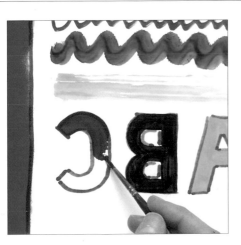

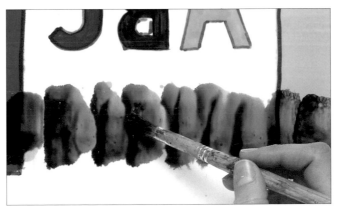

3 Use a bristle paintbrush to add some wavy lines and a fine brush to paint in the letters. Thin the ink slightly with kerosene (white spirit) to make it more fluid. To remove ink, use a cotton rag wrapped around your finger.

4 Use a wide bristle brush to paint further marks. Due to their transparent nature, a new color will be formed where colors overlap. Make sure there are no thick areas of color since these may spread when the plate is run through the press. Any thick or high areas of ink may be lightly blotted with newspaper prior to printing to strip off the excess.

Printing

5 Place the finished painting face-up on the press bed. Lay a sheet of paper over it and run it through the etching press. The paper can be dry, but you will get a better transfer of ink if the paper is first soaked and printed while it is damp.

Continued on next page

Monoprinting on Plastic
Alternative method using crayons

Tools and materials

You will need:
- Polyester drafting sheet
- Water-soluble crayons
- Printing paper
- Tray or sink for soaking paper (see p.15)
- Acetate sheet and marker (for registration, see p.17)
- Etching press (see p.10)
- Tissue paper
- Press blankets (see p.11)

Water-soluble crayons

Polyester drafting sheet

Tips

■ **Choose good-quality crayons since they will cover the areas a lot better. The color pigments will also be stronger, resulting in richer prints.**

■ **Always use quality paper. Mono-prints are one of a kind and if you use poor quality paper you may regret it.**

■ **The polyester sheet, if kept clean, can be used again and again for new monoprints.**

Preparing the sheet

1 Draw various circles onto the grained side of the polyester sheet using your selected crayon colors.

2 Apply enough pressure to lay down a good layer of color, and avoid leaving unnecessary gaps on the sheet.

3 Run the finished drawing through the etching press using dampened paper (see p.15). The press pressure should be similar to that used for etchings. Because the paper is damp, the crayon drawing will dissolve and transfer onto the paper.

Gallery

Monoprints by students at Dulwich College Preparatory School aged 12 and 13.

Monoprint by Pippa Smith.

Monoprint by Emma Clark.

Paper Plate Lithography
A low-tech introduction to litho

You will need:
- Paper litho plates
- Tracing paper
- Soft pencil
- Colored blackboard chalk
- Lithographic crayon
- Lithographic pencil
- Drawing fluid
- Fine brush
- Litho printing inks
- Putty (push) knife
- Suitable surface for mixing inks
- Ink roller
- Plate solution
- Cotton ball
- Newsprint paper
- Printing paper
- Etching press or litho press (see p.10).
- Tissue paper
- Press blankets (see p.11)

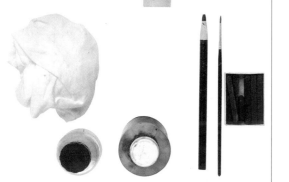

Litho plate paper (front & back), tracing paper, pencil, and colored chalk

Cotton rag, litho pencil, fine brush, litho crayons, bottle of plate solution, drawing fluid

Unlike intaglio and relief printing, lithography is a planographic process—the surface of the plate has not been physically altered in order to hold the image. Lithographic processes can also be used by the printmaker, and paper plate lithography has the advantages that it is inexpensive and involves no complicated processing steps.

The lithographic process works like this: a plate is drawn on with greasy drawing materials and then dampened with water. Oil-based ink sticks to the drawn areas but is repelled by the damp non-image areas.

For lithography you will need to buy specially made paper from a printmaking supplier, special liquid ink for making the plates (known as drawing fluid), and a special water substitute (known as plate solution). The drawing crayons and pencils are standard lithographic materials (see p.128 for a list of suppliers).

Another useful material is "transparent white," or "extender base," which is essentially a printing ink with no color. By adding colored lithographic printing ink to the transparent white it is possible to make a color lighter but keep it pure. These tints will alter any color they are printed over; for example a transparent red printed over a strong yellow will produce an orange tint.

In this project we show how to produce a two-color print from two paper plates. One plate is printed in light brown, one in dark brown.

Drawing the image

1 The image must be traced onto the plate in the reverse in this printing process. Make a tracing of the main design elements with a soft pencil onto tracing paper. To reverse the drawing, take a piece of colored blackboard chalk and cover the pencil lines.

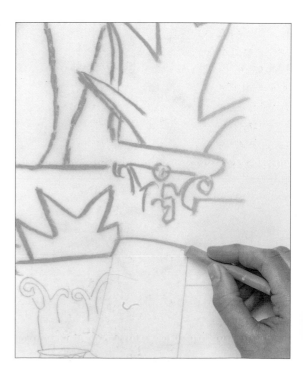

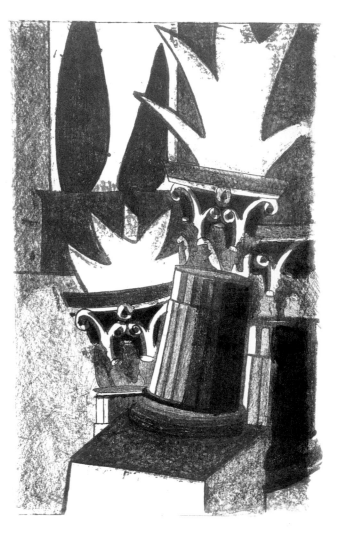

Two-plate two-color lithograph using paper plates by Andrew Bird.

2 Turn the tracing paper over and place it on top of the paper litho plate. Mark the corners of the plate on the tracing paper with crosses using a pencil.

3 Trace over the lines using a pencil; this will deposit a layer of colored chalk onto the plate. The chalk will serve as a guide for drawing with the lithographic ink, crayons, and pencils. Since chalk is non-greasy it will not affect the final print.

Continued on next page

Blocking in the image

4 Using the colored chalk lines as a guide, lay down a broad area of tone with the flat side of a litho crayon.

5 Add in fine lines using a sharpened litho pencil.

6 Lay down solid areas of dark tone with a fine brush and litho liquid ink.

The second plate

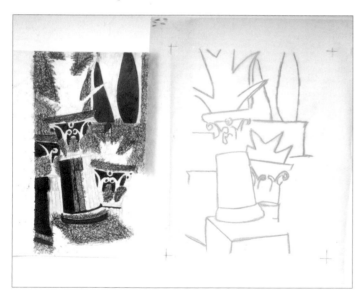

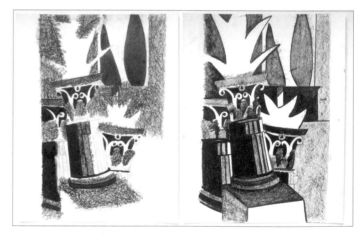

8 The second plate is drawn using the crayons, pencils, and ink (as with the first plate). The two plates are now ready for printing.

7 Using the original tracing, follow the same procedure to put the chalk sketch down onto the second paper litho plate. The two plates should be identical in size, so lining up the pencil crosses on the tracing paper with the corners of the plate guarantees the tracing is in the right position, and ensures the two plates are in correct register.

Inking the plate

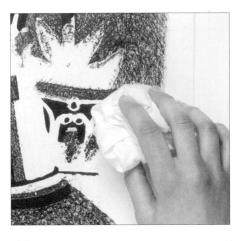

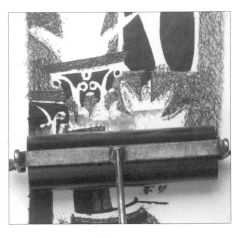

9 It is at this stage that the colors are mixed. The light brown color for the first plate is mixed from brown, red, and transparent white oil-based litho inks. Mix the ink with a putty (push) knife and make a swatch to test both the transparency and color mix by spreading a little ink onto a piece of scrap paper using the putty (push) knife blade.

10 The printing paper is made up of image areas (which have been drawn on) and non-image areas (where there is bare plate). When rolling the plate with ink it is essential that the non-image areas are kept damp, using the plate solution, which will repel ink, while the greasy drawing materials will repel the plate solution and accept ink. Using a cotton ball, dampen the plate all over with the fluid using a dabbing action.

11 With the plate still damp, roll ink over the surface. The ink will stick to the drawing materials but be repelled by the damp non-image areas. Recharge the brayer (roller) with ink for a second pass, re-dampening the plate before rolling again. (If the plate is not damp then ink will stick to the non-image areas. If this happens, do not panic! Re-dampen the plate and roll fast and light to pick up the ink in the non-image areas.)

Printing the plate

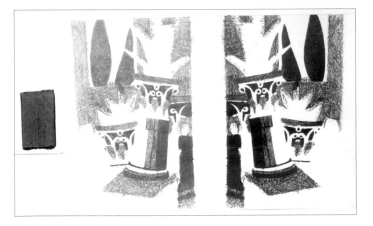

12 Place the plate on the bed of the litho or etching press. Print the image onto newsprint paper. The impression will be light, since several proofs must be taken to bring the image up to full printing strength. Redamp the plate and roll up the plate with ink again. Print a second impression, again onto newsprint. This impression should be darker than the first. Repeat this process, printing onto newsprint until the image is full strength. Three or four proofs might be necessary. Before printing onto good paper, mark out a backing sheet (see p.16). Print all the sheets required in the first color, making sure the plate is positioned on the backing sheet each time. The illustration above shows the color swatch, print, and inked plate for the light brown.

13 The second plate is then proofed in dark brown ink onto newsprint to bring it up to strength. The second plate is placed on the backing sheet and printed onto the paper with the previously printed light brown. All the sheets are printed to complete the edition. The color swatch, dark brown proof and second plate, are shown above.

Gallery

Monotype by student
Westminster School,
London aged 15.

Monotype by student at
Westminster School,
London aged 16.

Metal Plate Lithography
Planographic printing on zinc

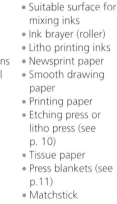

Zinc plate

Tusche stick

Gum arabic (processing gum)

Lithographic ink

White chalk, lithographic crayon, dip pen, toothbrush

Metal plate lithography is executed on sheets of either aluminum or zinc. The metal plates are considerably thinner than those used in etching (typically being $\frac{1}{48}$ in (0.5mm) thick) with a grained surface. Unlike paper plate lithography, which is capable of editions of up to 20 prints, metal litho plates can be almost endlessly printed and then regrained and used again. Metal lithography involves a processing stage where the plate's surface is chemically divided into two distinct areas— a greasy, ink-attracting image area and a water-attracting non-image areas. The main constituent in the processing solution is gum arabic, which forms a water-receptive layer on the non-image areas.

A variety of materials can be used to draw or paint images onto the plate. Lithographic pencils have a pull-down string which unravels the paper coating to provide fresh crayon when needed. These pencils can be sharpened to a point for fine detail work. Lithographic ink is used both to lay down areas of solid color and to lay down background tone using the spattering technique. Extremely fine fluid lines can be created by drawing with a dip pen and liquid ink. This ink is also available in a solid form, known as "tusche." This is mixed with distilled water and painted on the plate to create washes. Tusche also comes in bars known as "tusche sticks."

This project shows the basic marks possible using a piece of zinc printed on an etching press (see p.10).

Preparation

1 First, prepare the plate in a very diluted nitric acid or commercially prepared Prepasol solution. Dilute the nitric acid, mixing 400 parts water to 1 part nitric acid. Wearing protective gloves, pour the solution liberally over the plate into a tray, rocking the plate from side to side. Dry with a fan or hairdryer.

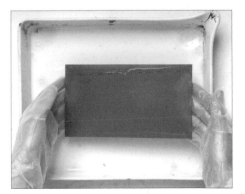

2 To be sure the margins stay clean, paint a border about $\frac{3}{4}$ in (20mm) wide on all four edges with gum arabic.

Continued on next page

Mark making

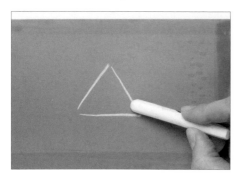

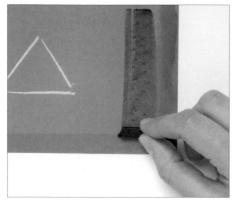

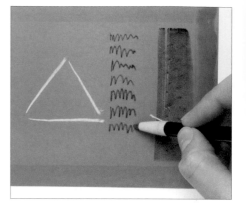

3 Use white blackboard chalk to plan out the image areas. The chalk acts as a guide for drawing with the litho crayons, pencils, and inks. It will not show when printed.

4 Lay down an area of tone using the side of a medium crayon. The crayon picks out the grained surface of the plate.

5 Use a lithographic pencil to draw a row of random, scribbled lines.

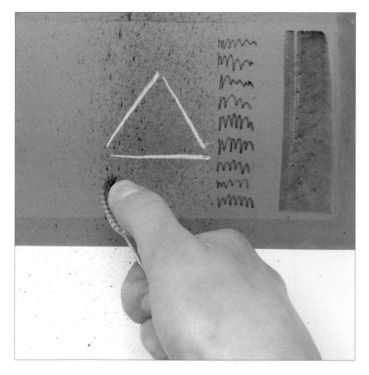

6 Flick liquid litho ink onto the plate using an old toothbrush.

7 To fill the triangle shape drawn with the chalk, paint in a solid color of lithographic liquid ink. Draw a row of fine lines with a dip pen and ink.

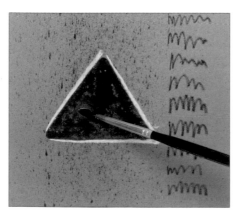

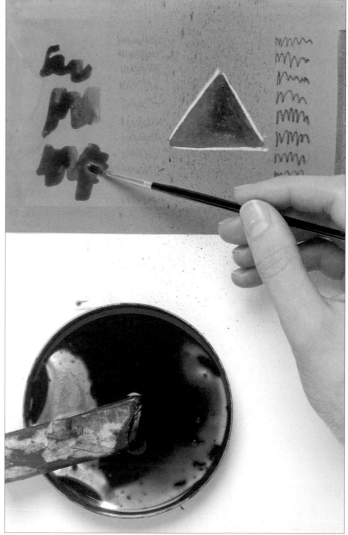

8 To add washes, use a tusche stick to create a tusche wash. Apply this to the plate with a fine paintbrush. Let the plate dry before proceeding.

Processing

9 Dust the image lightly with powdered rosin, (resin) then dust with French chalk. These fine dusts stick to the greasy drawing particles, protecting them from the acidic processing gums which follow.

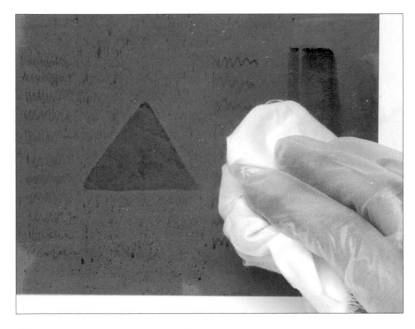

10 With a clean cotton rag, dab gum arabic over the entire plate, then buff it down to a thin layer. Let the plate stand for at least 30 minutes. Take a rag soaked in kerosene (white spirit) and gently rub into the drawn areas; the drawing will begin to dissolve.

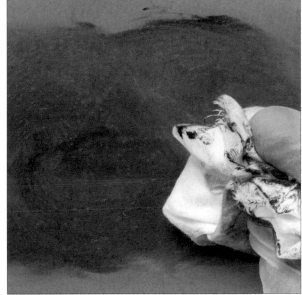

11 When all the drawing has been removed, rub a little liquid asphaltum over the image areas. This will act as a key for the ink.

12 Now remove the gum coating (which has been protecting the non-image areas from any contact with grease while the drawing material was removed). Do this using sponge and water.

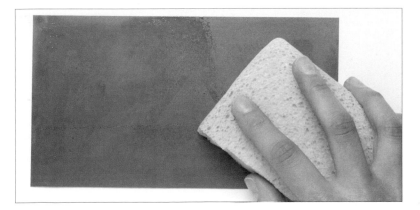

Continued on next page

Printing the proofs

13 Keeping the plate surface evenly damp roll the plate with black proofing ink. If you forget to damp the plate before rolling, the ink will fill-in the non-image areas. If this happens, damp the plate and roll quickly and lightly to remove the unwanted ink. This ink is a processing ink, not a printing ink.

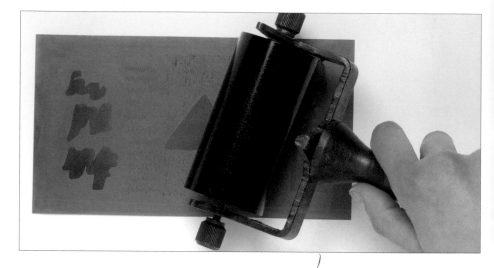

14 Ink the plate and run it through the press onto a sheet of newsprint, with two or three sheets of thin smooth drawing paper on top to act as packing. Add extra sheets to increase pressure if necessary. The first proof will be pale; dampen the plate with a sponge and re-ink. Proof again onto newsprint. It will take three-to-five proofs to reach full tonal strength. To ensure clean edges, lay strips of tissue over the plate edge where the gummed margin was.

15 When the plate has reached full strength black it is time to assess the image. You have three choices. Does anything need erasing, does anything need adding, or is everything as it should be? To erase small areas, gently rub the area with a lithographic hone or a small wooden stick (such as a matchstick) dipped into erasing solution. Let the erasing solution stay on the area for a minute or two then wipe away with a sponge and water. To add more drawing, the plate must be dusted with rosin (resin) and French chalk and re-prepped using a strong prepping solution (one part Prepasol to seven parts water). Drawing may then be added.

Whether you have made alterations or not, the plate is given a second gum etch to stabilize it—dust the plate with rosin (resin) and French chalk, and then gum as before.

Printing in color

16 To finally print the plate in color, mix up the required litho proofing ink. Remove the proofing black from the plate with kerosene (white spirit) and a rag, and wipe in a little asphaltum. Remove the gum with a sponge and water and ink the plate in the usual manner. The image needs to be built up slowly again on newsprint by printing three or more times. When the image is at full strength, print the edition. Register the prints using a backing sheet (see p.16).

Register the prints using a backing sheet (see p.16).

Tip

To store a plate for future printing, roll it with non-drying proofing black, French chalk it, and gum with plain gum arabic.

Gallery

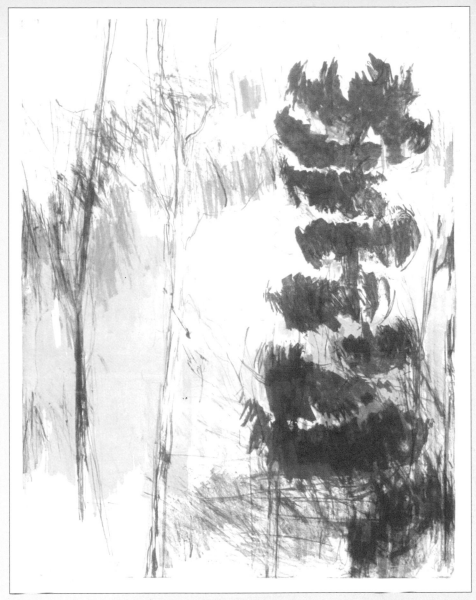

Plate lithograph in four colors
by Rachel Gracey.

Plate lithograph in ten colors
by Colin Gale.

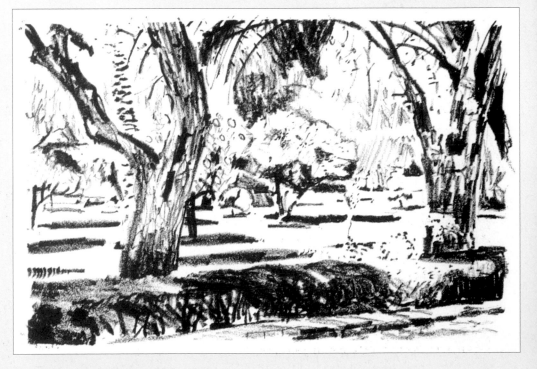

Plate lithograph by Steve White.

Post Production: Drying Prints

How to stack or hang the wet paper

Relief prints

The surface of relief prints will be very wet immediately after printing and nothing should be allowed to come into contact with the inked surface.

Ball racks are an ideal way to dry relief prints. The print is hung from a wooden rack, with the dry border of the print being gripped by a glass ball. The advantage of these ball racks is that they are space saving since they don't use floor space.

A simple drying system for relief prints can be made by using clothes pegs suspended on string. Use two pegs to hold each sheet of paper.

If the inked area covers the complete paper surface, however, the prints must be dried horizontally. In that case, wire stacking racks which are designed for drying screen prints should therefore be used.

Prints are left until the ink is dry to the touch, and this may take several days. The more layers of ink there are the longer the print will take to dry.

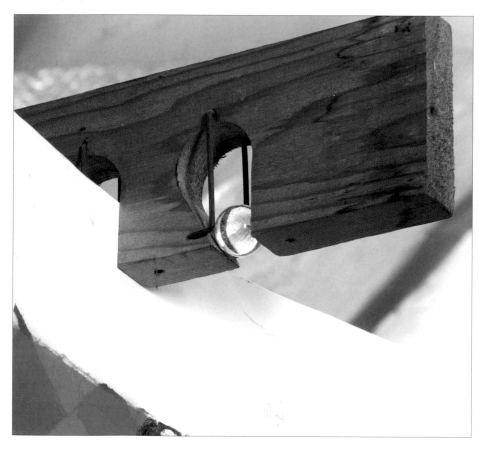

Ball racks (above and right) are an ideal way to dry relief prints. The prints are suspended from a wooden hanging rack, and are held in place by a marble. The marble is pushed up to release the paper.

Lithographs

The amount of ink deposited during printing is much less with lithographs than with relief prints. Lithographs can therefore safely be stacked on top of each other, as long as they are interleaved with sheets of tissue. Ball racks or tray racks can be used if you have access to them because the prints will dry faster this way.

Screenprints

Screenprints are dried flat in drying racks designed for this purpose. Screenprint ink dries by evaporation so drying time depends on atmospheric conditions. Compared with other print processes, silkscreen prints dry quickly (usually in less than an hour).

Etchings

After printing, etchings should be covered with tissue and dried between clean sheets of blotting paper. Make a stack of prints to be dried, each covered by tissue and sandwiched by blotting paper. Flatten the pile with a wooden board, place weights on top, and leave for several days. If prints are removed too early they may cockle. If this happens the print may be safely soaked again in water, carefully blotted, and dried again. Always use acid-free tissue and blotting papers.

Dry etchings by interleaving sheets of tissue and then blotting paper between each print.

Post Production: Framing

Choosing a suitable mounting style

A good frame will show a print at its best; a bad frame can spoil it. A print may well be left in the same frame for many years so it does not make sense to economize at this stage. It is well worth using the services of professional framers, since they will have the proper equipment for precision mitring and mat cutting.

As well as presenting a print, a frame must also conserve the work. The paper must be framed so that it is not in contact with the glass, since this can cause condensation problems. This is achieved using two different styles of framing. The print can be framed with the paper behind a window mount of matboard, or alternatively a box frame can be used where the print is floated on board and distanced from the glass by wooden fillets. The style of the work will usually determine which framing system is best. Make sure the framer uses acid-free board and uses acid-free tape to fix the print in position. With window mounts, choose a neutral-colored acid-free matboard, and give precise instructions regarding border spacing around the print. A print needs to breathe so should not be too tightly framed to the image. Allow borders of at least 3½ inches (90mm) side and top and 4½ inches (110mm) at the bottom.

Have in mind the type of molding and finish you want. A framer will have samples which you can simply hold up to the corner of your print to see which looks best. Framing should be chosen in relation to the image. The image must be the focal point, so the print should not be over-powered by the color or design of the frame. Often a simple molding in natural waxed wood such as ash or oak will prove the best. Wood can also be stained with finishes varying from lime-wax white to brown and black shades.

Above: a box frame made from lime-waxed natural wood.

Left: window mats can be used to distance the print and glass, but special cutting tools are required in order to get a professional finish.

Above: professional framers will have right-angled samples of frame molds which can be held around your prints to see which style suits your work best.

Post Production: Storing Prints

Taking care of unframed prints

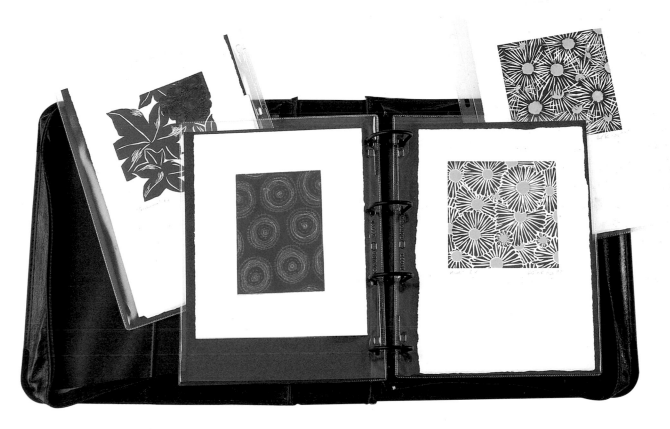

Once prints are totally dry they can be stacked one on top of the other with acid-free tissue in between each. Always make sure that your hands are clean when handling prints, and that the paper is handled with care to avoid damage to the edges and corners.

To transport prints, specially-designed flat portfolios with internal plastic sleeves can be purchased from good art suppliers. Alternately, effective portfolios can easily be made by using two sheets of acid-free matboard, which are taped together on three sides.

To present prints for display in a shop, exhibition, or on a market stall where they will be handled by the public and potential purchasers, back the prints with matboard and wrap them in clear cellophane, the type that florists use for wrapping flowers. This will show

prints well and ensure they are not damaged by constant handling. This is an ideal form of protection and presentation if a number of prints are going to be put in a print bin for people to flick through.

Perhaps the best place to store prints at home or in the studio is in a flat files (plan chests). Flat files are specially designed for storing paper, and are usually constructed of wood with six or eight drawers. As well as being practical, they are often attractive pieces of furniture.

Index

Suppliers and acknowledgements

USA

American Printing Equipment &
Supply Co.
42-45 9th Street
Long Island City, New York
11101-491
Tel: 718-417-3939
www.americanprinting-
equipment.com
Printing supplies

Daler-Rowney US
2 Corporate Drive
Cranbury, New Jersey
08512 9584
Tel: 973-373-4279
www.daler-rowney.com
Screen printing system -
transparent base and acrylic
paints

Daniel Smith Inc.
4130 1st Street South
Seattle, Washington
98134
Tel: 206-223-9599
www.danielsmith.com
General printmaking materials

Graphic Chemical & Ink Co.
P.O. Box 278
Villa Park, Illinois
60181
Tel: 708-832-6004
www.graphicchemical.net
General printmaking materials

Legion Paper
11 Madison Avenue
New York, New York
10010
Tel: 212-683-6990
www.legionpaper.com

Printmaking papers
Rembrandt Graphic Arts
P.O. Box 130
Rosemount, New Jersey
08556
Tel: 609-397-0068
www.rembrandtgraphicarts.com
General printmaking materials

TW Graphics
7220 East Slausen Avenue
City of Commerce, Los Angeles
900 40
Tel: 818-344-6663
www.twgraphics.com
Screen printing supplies and
inks

UK

Artichoke Print Workshop
Bizspace S1
245a Coldharbour Lane
London
SW9 8RR
Tel: 020 7924 0600
www.printbin.co.uk
Open access workshop and
courses

Daler Rowney Ltd
P.O. Box
Bracknell
Berkshire
RG12 8ST
Tel: 01344 424621
www.daler-rowney.com
Screen printing system - base
and acrylic paints

Intaglio Printmaker
62 Southwark Bridge Road
London
SE1 OAS
Tel: 020 7928 2633
General printmaking supplies

John Purcell Paper
15 Rumsey Road
London
SW9 0TR
Tel: 202 7737 5199
www.johnpurcell.net
Fine art paper merchant

Openshaw International Ltd
Woodhouse Road
Todmorden
OL14 5TP
Tel: 01706 811440
www.openshaw.co.uk
Chemicals and printing
sundries

R.K. Burt & Co
57 Union Street
London
SE1 0AS
Tel: 020 7407 6474
www.rkburt.co.uk
Fine art paper merchant

Sericol
Westwood Road
Broadstairs
Kent
CT10 2PA
Tel: 01843 866 668
www.sericol.co.uk
General screen printing
supplies

T.N. Lawrence
208 Portland Road
Hove
East Sussex
Tel: 01273 260 280
www.lawrence.co.uk
General printmaking supplies

Acknowledgements

The authors wish to thank the
following for allowing their
work to be reproduced in this
book:

Margaret Auerback
Joss Bassett
Elin Bjorsvik
Andrew Bird
Paul Catherall
Paula Cox
Emma Clark
Anne Catherine Le Deunff
Meg Dutton
Susan Einzig
Megan Fishpool
Ray Gale
Rachel Gracey
Emma Grover
Ruth O Donnell
Isobel Huchison
Maxim Kantor
Caroline King
Anita Klein
Jo de Pear
Pippa Smith
Hugo Shakeshaft
Susan Short
William Thomas
Erika Turner-Gale
Ruth Uglow
Paula Vokes
Steve White
Simon Whittle
Alan Wilkie
Joseph Winkelman
Sheila Yorke